THE BEST POSSIBLE FACE:
L.B. FOOTE'S WINNIPEG

The Best Possible Face
L. B. Foote's Winnipeg

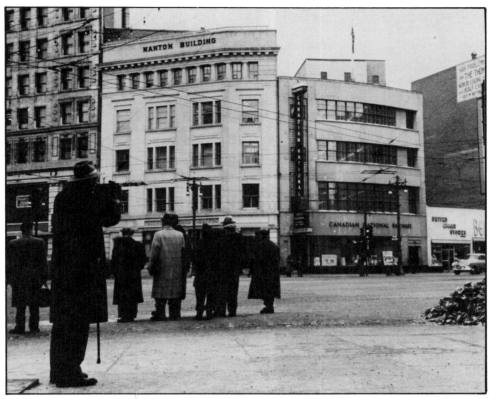

Doug Smith & Michael Olito

TURNSTONE
PRESS

Published with the assistance of the Manitoba Arts Council
and the Canada Council.

Turnstone Press
603-99 King Street
Winnipeg, Manitoba
Canada

This book was typeset by B/W Type Service Ltd. and printed by
Hignell Printing Ltd. for Turnstone Press.

Printed and bound in Canada.

Design: Steven Rosenberg

Canadian Cataloguing in Publication Data

Foote, L.B. (Lewis Benjamen), 1873-1957
 The best possible face

I SBN 0-88801-097-4

1. Winnipeg (Man)—Description—Views. I. Smith, Doug 1954-
II. Olito, Michael 1942- III. Title
F C 3396.37.F66 1985 917.127'4'00222 C85-091440-X
F 1064.5.W7F66 1985

Turnstone Press acknowledges The Western Canada Pictorial Index,
University of Winnipeg, for the photograph appearing on the first
page of the Introduction; and the Provincial Archives of Manitoba:
Foote Collection, for all other photographs.

Introduction

IN 1902, WHEN THE YOUNG LEWIS FOOTE stepped off the train at the CPR station, he was one more immigrant hoping to make his fortune in frontier Winnipeg. He was arriving at the beginning of two decades of boom and boosterism, riot and reform, industry and indulgence. The city boasted of its self-made millionaires, men who had come to a muddy village on the Red River and created enterprises that covered the prairies. Foote never became a millionaire, but during a career that spanned fifty years, he did become the city's premiere commercial photographer. The images we have of our past are almost exclusively L. B. Foote's images. The General Strike, the visits of royalty, the stately homes of Wellington Crescent, the squalor of the North End—we know them through the work of this affable, energetic, and extremely respectable freelance photographer.

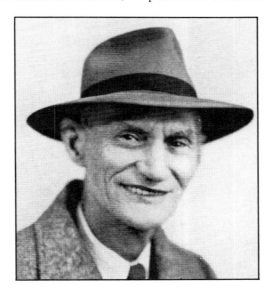

L. B. Foote, 1873-1957

The Commercial City

IT SHOULD NOT BE SURPRISING that this recorder of turn-of-the-century Winnipeg was a commercial photographer. As the city's historian, Alan Artibise, has noted, Winnipeg was run by businessmen who viewed a city as little more than "a community of private money-makers." When Lewis Foote arrived, boosterism was at its height. Winnipeg was going to be the "Gateway to the West," the "Last Best West" and the "Chicago of the North." The city verged on a spurt of growth that would in ten years vault it to the position of the third largest city in Canada. Some of its residents were starting to sound a note of alarm. In 1911 Winnipeg journalist Vernon Thomas wrote: "Her mad passion for evidences of expansion, her insistent demand for figures to improve growth, be it by building permits, or by bank clearances, or by customs receipts, or by pavement mileage, or peradventure by the price of vacant land, any process of growth demonstration, have blinded her to the fact that cities cannot live by growth alone."

And the years of growth soon became the years of social crisis. The new immigrants were not always the 'good British stock' that Winnipeggers envisioned as the foundation of their society. By 1911 Winnipeg had the highest percentage of foreign-born residents of any city in Canada and the highest percentage of German and Jewish immigrants. The new Canadians, who had been recruited to do the West's low-paid spade work, digging ditches in the cities, clearing wilderness on marginal land and laying railway across the country, were jammed into slum housing in the city's North End. Theirs were lives of not-so-quiet desperation. Through their unions and radical political parties, they started agitating for their share of the good life they had been promised in Canada. At the best of times they were the butt of jokes and discrimination; during the patriotic hysteria of the first world war they were interned, thrown out of work and even deported.

Politically it was the age of the great boondoggle, when votes were bought with beer and private detectives spied on cabinet ministers. The government of Sir Rodmond Roblin, which held office for fifteen years thanks to a skillful combination of vote-buying, ward-heeling and out-and-out fraud that would have done Tammany Hall proud, came tumbling down in the legislative building scandal of 1915. In exchange for campaign contributions, the government overpaid the building's contractor by over $700,000. In the midst of his inquiry into the affair, Manitoba Chief Justice T.A. Mathers confided to his diary that "the story told was a sordid one, implicating Roblin, Montague, Coldwell, Howden, Kelly and Dr. Simpson in a conspiracy to defraud the province of a large sum of money."

And while businessmen were trying to turn Winnipeg into the Chicago of the North, protestant clergy men, inspired by the social gospel, aimed for nothing less than the Kingdom of God on Earth. Methodist minister Salem Bland managed to get himself fired from Wesley College for his feisty assaults on the establishment, which peaked with his telling the well-heeled congregation of Grace Church that "you cannot expect a businessman to live a Christian life today." For all that, it was a contradictory and very narrow minded sort of reform movement, seeking on one hand to give women the vote and on the other to "ban the bar," to oppose conscription and yet to make English the only language of education in the province.

The city's motto was "Commerce, Prudence, Industry," but its public life was dominated by conflict over class, culture and religion. The social reformer's vision of the New Jerusalem jostled uneasily for space next to the real estate agent's Last Best West. Lewis Benjamin Foote would try to put the best possible face on such a city.

The Man who Foote-e-graphes the People with a Smile

ERHAPS NO ONE COULD HAVE BEEN BETTER SUITED to such a task. An immigrant from a British colony, a charter member of the Nova Scotia Branch of the Ancient Order of Foresters, an unschooled, self-taught, religious entrepreneur— Lewis Foote shared all the virtues and foibles of the Winnipeg commercial elite.

He was born in 1873 in Foote's Cove, a small island community off the coast of Newfoundland. His father was the captain of a Grand Banks fishing schooner and his mother was a teacher. Bored by his lessons, he dropped out of school at the age of twelve to try life on his father's fishing boat. Within two years he was looking for new adventure, and left Newfoundland, stowed away aboard a schooner bound for Prince Edward Island. There, working as an office boy on the Summerside *Journal*, he developed his lifelong affection for the world of newspapering. And it was in Charlottetown that he discovered both photography and his entrepreneurial flare. For Lewis Foote, it seems the two were always linked: in a brief autobiography of his early years he made no mention of where or when he took his first picture, or what he thought of photography, but he outlined in some detail his early photographic business ventures. In the first of these he convinced a local photographer to let him go door-to-door selling half-price coupons on photographs. He claimed the enterprise netted him $1,200 in three months. He soon moved to Halifax and in quick succession found and quit jobs working in a bakery, driving a delivery wagon, and selling Christmas cards and silverware. It was during his spell as a salesman that he made the discovery that "I liked meeting people and doing my own business." At the age of sixteen he invested his savings in his first camera and went into business with a local painter, Carl Jenson. Foote would take a picture and enlarge it, then Jenson would use it as the basis for a portrait that he would in turn sell for $50.

Foote was fascinated by the emerging technology of the Twentieth Century. He bought one of the first phonographs in the Maritimes and ordered two dozen headsets to go with it. Thus equipped, he started touring local fairs, charging people twenty-five cents to listen to his recordings. He also taught himself to play the autoharp and soon was not only giving concerts but making a sideline income as an autoharp salesman. He credited his skill on the autoharp and his entertaining abilities for his success in organizing six Courts of the

Order of Foresters when he was in Nova Scotia. He was an adventurous, smooth-talking young man, and like many such young men at the turn of the century, he was interested in what the West had to offer.

In 1899 he married Mary MacKichan, a nurse from Nova Scotia. Shortly after, his father-in-law, a protestant minister, was transferred to Moose Jaw, Saskatchewan. Lewis and Mary visited them in 1901, and moved to Winnipeg the following year. After a period of office work with the Canadian Pacific, Foote resurrected a photo-marketing gimmick from his maritime days. He took pictures of every church in Winnipeg and superimposed portraits of the ministers on the prints, then sold the pictures to the churches. Finally he had settled into his career. After a brief spell with the Winnipeg *Telegram* he worked almost solely as a freelance commercial photographer.

To drum up business, Foote would frequent picnics, parades and parks, distributing small advertising cards, distinguished by their crazy slogans and doggerel verse. The cards celebrated the man "Who Foote-e-graphes the people with a smile". One verse described an Orange picnic in Winnipeg:

See them gather round in line, Dolly Dear
Start with Portage hand on time, Dolly Dear
Shouts the marshall of the day
Forward march, hip, hip, hurrah!
Is re-echoed by the way, Dolly Dear
Stores and banks are emptying out, Dolly Dear
Business has gone up the spout, Dolly Dear
(G. M.) Sharp shakes Mayor Brown's hand
As they fill the great grandstand
Attention! Boys, hats off, they sang, Dolly Dear
CHORUS
Good day Portage, glad to greet you
See those thousands coming nigh
Flags and banners widely floating
With sounds of drums that reach the sky
Watch those faces filled with brightness

With firm and steady pace march by
In memory of their great commander ready to do or die
L. B. Foote, 328 Vaughan St., Winnipeg
Remember I am a UNION 243 man and I am here to take your PHOTOS.

Other cards included odes to the Eaton's staff picnic of 1907 and an all-purpose one titled the "Latest Park-re-et-ic Song," that he distributed at any park gathering. The last line urged people to "dream of the photo man's address, Phone number 1479."

In 1909 he went into partnership with another local photographer, George James. James handled the studio work, leaving Foote free to roam the city on commercial assignments. It is from such assignments—the arrival and departure of the famous at the train station, weddings and funerals, the construction of a new building, the opening of a new shop, a staff dinner or picnic—that Foote's tremendous collection of photographs grew. The partnership with James was interrupted in the early 1920s when Foote moved to California in search of different work. There he worked on some early Chaplin films, taking publicity stills, but he was soon back in Winnipeg, doing commercial work with James.

Foote often commented that his happiest jobs were "taking pictures of a family history—a little girl, then a picture of her as a bride, as a mother, of her daughter as a child and then a bride. I like to remember those shots just as much as the important ones." But while those may have been his happiest pictures, the ones he seemed proudest of, and the ones which made his reputation, were his portraits of visiting royalty.

His work with royalty began in 1901 when he photographed the future King George V and Queen Mary when, as the Duke and Duchess of York, they toured Canada with Sir Wilfrid Laurier. But his close acquaintance with the royals dates from 1918 when he was the official photographer for Prince Arthur, the Duke of Connaught, on his tour of northern Ontario. The trip provided Foote with one of his favourite and often-repeated royal anecdotes. On a portage near Lake Nipigon the Prince took a tumble and tore

the seat of his trousers. He kept on hiking, unaware of the damage, until Foote called out, "Your Highness, your bay windows are showing." On the same trip, Foote nearly drowned taking a picture of the Prince hauling in a catch of trout.

The following year the young Edward, Prince of Wales, made a Canadian tour. Foote used a letter of introduction that Prince Arthur had given him to make Edward's acquaintance, and photographed the Prince's visit to Winnipeg, including one picture of the Prince in an Indian headdress. Although he was invited to travel with the royal train to the west coast, Foote had to beg off due to other commitments. Nevertheless, he joined the Royal Party in Vancouver.

He took one of his most famous pictures on the Royal Yacht as it steamed from Vancouver to Victoria. He had been commissioned to take an exclusive photograph for the *Times of London*. He told the Prince's aides that he wanted to portray the Prince in his naval uniform. It was unlikely, they said. The Prince did not like the way the uniform fit and avoided wearing it. But Foote used the skills he had honed on the doorsteps of Charlottetown and in the fairgrounds of Nova Scotia. He suggested that the people back in England might like the picture more if he wore the uniform. At last the Prince consented, "All right, Foote, I'll put it on." The image of the wistful-looking Prince became Foote's most famous picture. At a latter reception on the tour, the Prince saw Foote carrying a number of prints of the picture and asked him how much the prints would cost. In years following, Foote took pleasure in recounting that he had turned to the Prince and told him, "Let's see, six prints at $5 a picture, that'll be $30."

But it is not for his photographs of royalty that Foote is remembered today. His most reproduced work comes from the Winnipeg General Strike, particularly his series of photographs documenting the events of Bloody Saturday. Mayor C. F. Gray had banned parades and demonstrations, but the strikers decided to hold a silent parade to protest the arrest of the leading members of the strike committee. Foote was down on Main Street that day and stationed himself on the third floor of a building near the corner of Portage and Main. From there he captured, frame by frame, the bloody climax of the strike.

Unable to disperse the crowd, Mayor Gray called on the Mounted Police to restore order. In Foote's pictures we see the Mounties, truly Mounties—on horse-back if not in red tunics—pass through the crowd several times. We see the angry strikers overturn a streetcar being operated by scabs. We see the police charge the crowd at a gallop, at first simply with batons and then with batons and pistols. Two men are lying on the ground, the streetcar catches fire, and then hundreds of special police move in on the strikers. J. S. Woodsworth called it 'Kaiserism in Canada'. Today, in our search for heroes who challenge the establishment, we tend to side with the strikers. But it is likely that Lewis Foote was rooting for the forces of law and order. Foote's account of the day underscores the risks he was willing to take to capture the event. "Someone was shooting at me from across the street. I presumed it was a striker who didn't want me to get any pictures. Three bullets were fired—one went through the window above my head and the other two struck the building."

Photographing the General Strike was not Foote's only dangerous assignment. Perhaps he got his taste for heights from the days he used to run up and down the masts on his father's schooner because he always seemed willing to suspend himself from the top of a new building to get a panoramic shot of the city. For his picture of the workmen putting the sheathing on the Hotel Fort Garry, he had to creep to the end of a long plank which stuck out one of the hotel's windows and was held by some of the workmen. Once he was perched on the new chimney of the city's steam generating plant, preparing to take a shot, when an updraft scattered the planking he was standing on and left him hanging from the chimney's lip. For another picture he straddled a load of lumber that was dangled from a construction crane on the top of the McArthur Building. The line holding the load dropped a link and, in Foote's words, started to "bronco" 300 feet above the city. He held on to the load

and his camera and got the picture he wanted.

There is still another dimension of Winnipeg that is documented by Foote's work. Anyone who casually flips through the Manitoba Archives' collection of Foote photographs has a grisly shock in store. For cheek by jowl with photos of picnicking families and visiting service clubs is a horrifying gallery of stark, violent death. For a quarter of a century Foote was the official photographer to the Winnipeg coroner. The job brought him to dozens of murder scenes, where he faithfully recorded the corpse in the position it had been found. It must have been a disturbing job. But in interviews Foote was light-hearted about the work. "One thing about these people. You never have to tell them to smile, you never have to tell them to keep still and they never complain that the proofs don't look like them."

By 1930 Foote's most creative and prolific years were over. He continued as a freelance photographer, but more and more his work consisted of portraits of visiting dignitaries, either at the CPR station or with the lieutenant-governor. A 1948 car accident left him with two broken legs, effectively putting an end to his career. In his later years he kept up a lopsided correspondence with many of the famous people he had photographed. By the time of his retirement he had come to be known as the "dean of Canadian press photographers" and his work was the subject of a number of retrospective articles in Winnipeg newspapers. He died in July of 1957 at the age of 84. A cable of condolence from the Duke and Duchess of Windsor arrived in Winnipeg only hours after he was buried.

The Foote Collection

LEWIS FOOTE LIVED THROUGH THE AGE of Manitoba's great reform movement when women won the vote, when liquor was prohibited, when labour rose up angry. But he was not a reformer with a camera. His work documents the tremendous social change of the era—the crushing of the strike, the shots of North End slums he took for J. S. Woodsworth's books, the

interiors of the CPR shops—but these are usually commissioned works. We see the workers the way the boss would like us to, lined up in rows, often in their Sunday best; only on rare occasions do we see anyone doing actual work. Foote is the recorder of orthodoxy and Angloconformity; if he can be said to have a predominant subject for his photos, that subject would be private property. The voice we hear in so many of his pictures is that of the person writing the cheque for the print. He, and it is most certainly he, is saying: I am a man of substance, I own this house, this is my wife, and these are my children; this is my factory, these are my workers. I can have my photograph taken. I am respectable, God-fearing and hard-working.

So the question arises, did Lewis Foote have any particular vision or did he simply give the people what they wanted? Was his astounding collection of photographs just coincidence, the result of fifty years of grinding out a living with his camera? That can only be part of the answer. In many ways the work of L. B. Foote seems like inspired Babbittry. It is full of portraits of celebrating Elks, Oddfellows and Kiwanians. He was there for the opening of the Pine-to-Palm cavalcade designed to connect Winnipeg with tourist dollars in the southern United States. We can imagine Foote joining the boys from the *Telegram* newsroom in the press club for an evening of royal reminiscences. He never ridicules these men in his pictures; to do so would be unthinkable, but time has turned the bluff confidence that these men exude into something bordering on self-parody.

In some of the pictures, we see clearly the victory of those who wanted to assimilate the "foreigner". The students at Aberdeen School represent 21 nationalities, but so thoroughly have they all been "Canadianized" that one would never know it by looking at them. Could there be a greater advertisement for the powers of the melting pot?

There is a seductive quality in other pictures, tempting us to luxuriate in the Andy Hardy world of the past. Who wouldn't want to live in a world where the grass is so lush that outfielders can't field ground balls, where so many healthy babies are lined up so perfectly, where the milkman and faithful Dobbin come every

morning? The men and women look so fresh and smart at the canoe club, the inner city garden simply invites midnight garden raids.

But death and violence were present in this idyllic past. The General Strike was not a one-time-only event; for decades to come civic politics was merely the strike carried on by other means. And the milkman often brought contaminated milk, striking down countless children in their second summer. And crime meant more than the quaint and colourful offense called bootlegging; back then there was murder and inexplicable death. The optimism of much of Foote's work is sometimes belied by the photographs of those who are on the edges of Winnipeg society. The visiting black boxer, the old man outside his shack reading the *Telegram*'s special edition on homes, the convalescents, the young criminals, speak of the despair and disillusionment to which the boosters turned a deaf ear.

Looking through the work of Lewis Foote, we see a middle-class Winnipegger ordering his world. Yes, there is poverty, but the Methodists are dealing with such problems. There is murder, there is death, but there is the coroner and the white casket, rituals to make it all more understandable. And when the city starts to lose its vitality, curiously, Lewis Foote loses his as well. By the mid-twenties his pictures are becoming less and less interesting. He becomes less the city's photographer and more of a court photographer, snapping the lieutenant-governor and the premier with countless officials, from the King of Siam to Mackenzie King and his mother.

The inability to rise above commercialism was not Lewis Foote's failure alone, it was also Winnipeg's failure. But that does not rob either of their vitality. For however harshly we may judge the merchant princes who dominated early Winnipeg, the strength and sense of self-importance of their vision cannot be ignored. The stamp they left on Manitoba society seems to be indelible. The artistry of Lewis Foote leaves a similar imprint; it is confident and assertive, bold and celebratory. And in his best work there is a power and compassion that cannot be denied or forgotten. His images are still our images.

In the charmed and haunted world of "the man who Foote-e-graphes people with a smile", we can savour the aspirations of the past and examine the roots of the present.

c. 1915. Cheshire Dairy delivery wagon.

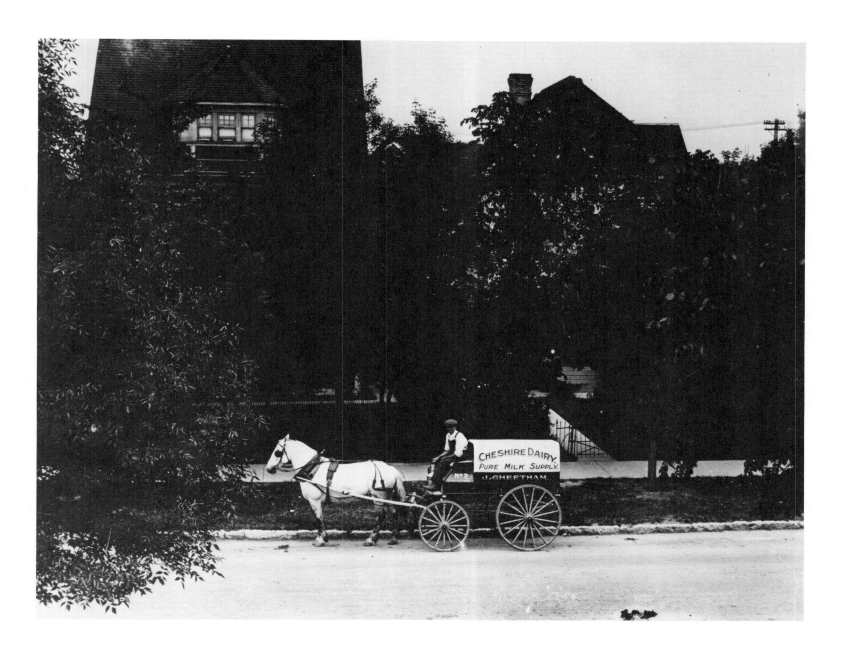

c. 1913. Girl having her hair dried.

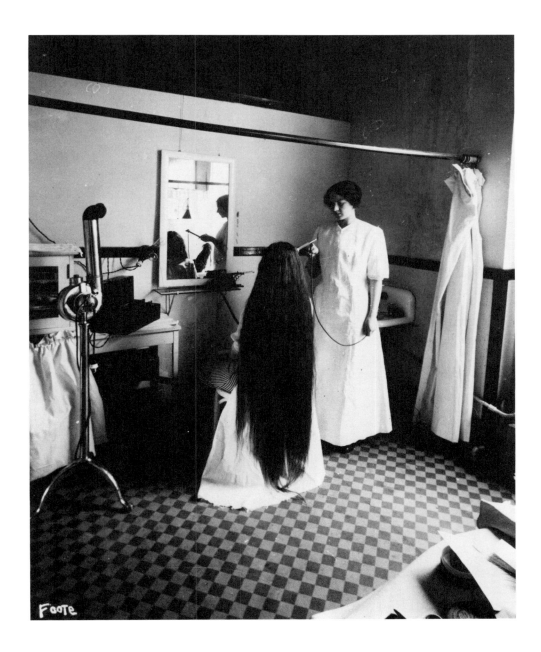

1912-1913. Copper sheathing the roof of the Hotel Fort Garry.

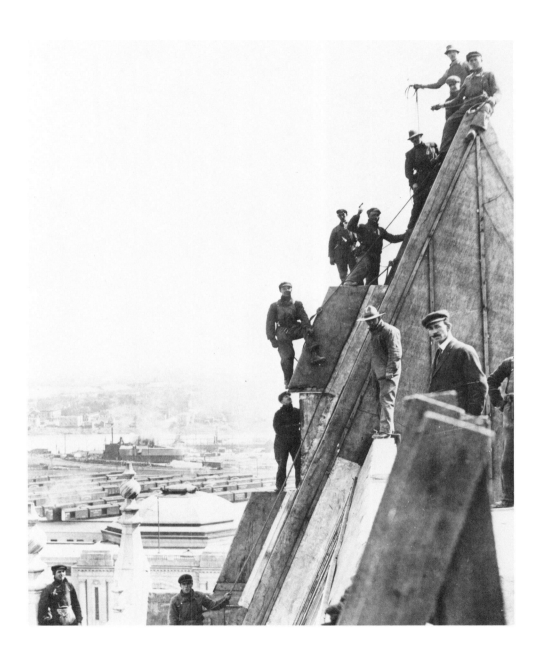

Winnipeg, Winnipeg, Gateway of the West
Always growing greater, never growing less
Winnipeg, Winnipeg, we are not so slow
We are always boosting, everywhere we go!
 —cheer of the Young Men's Section of the Winnipeg Board of Trade

c. 1915. Manitoba Motor League's Booster Tour car.

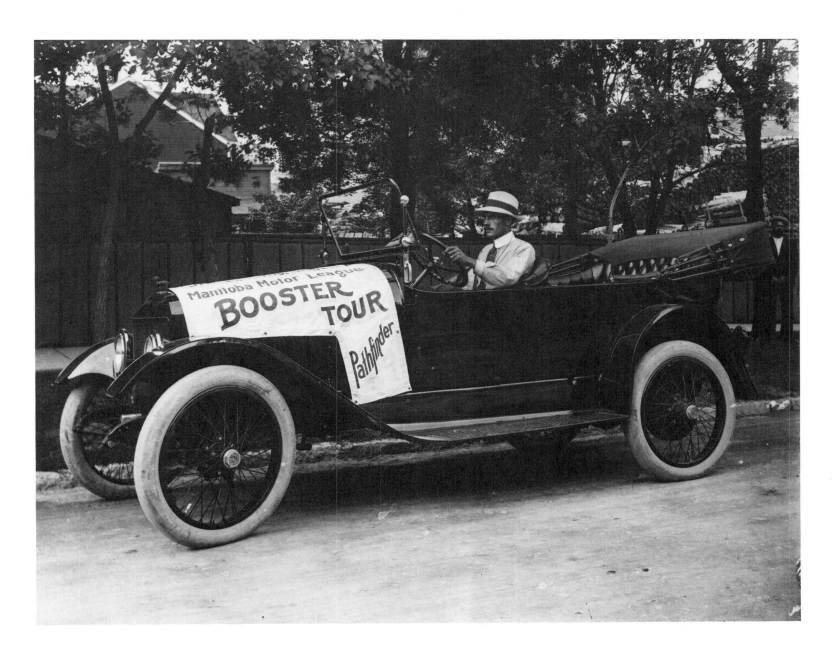

February 5, 1916. Snow clearing, Carlyle sub-division of C.N.R. line.

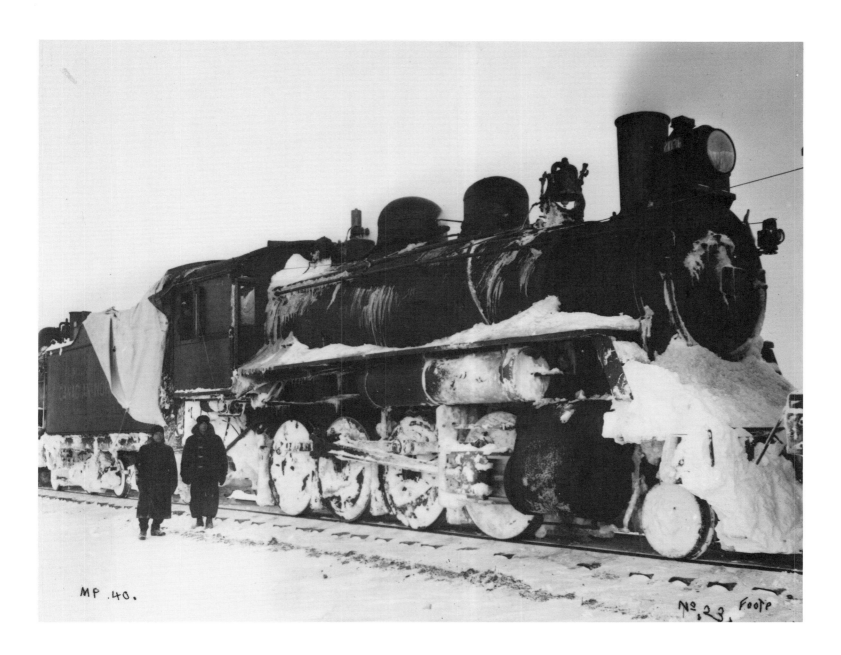

MP. 40. Nº 23. Foote

1922. Sheep at Union Stock Yards.

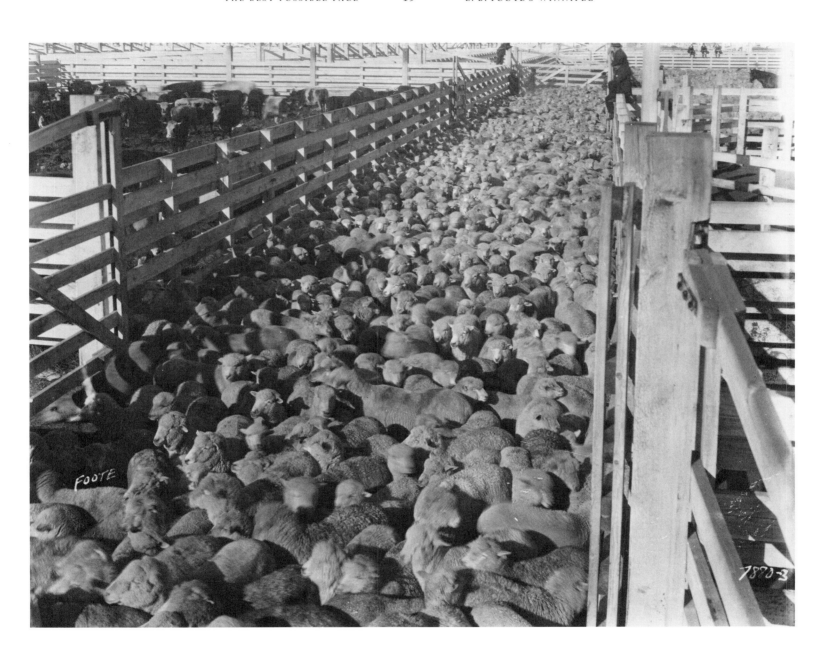

January 2, 1921. Fox farm.

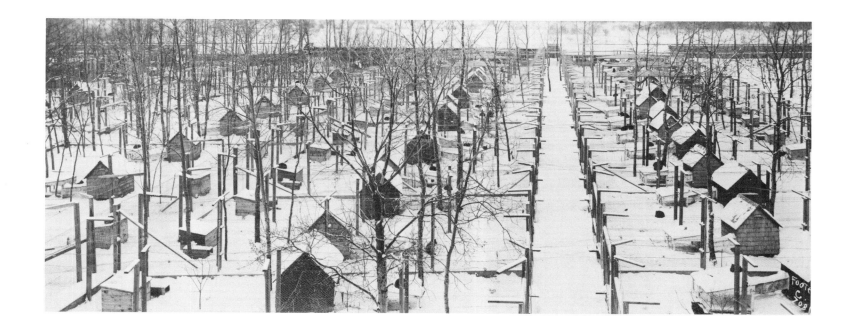

c. 1912. Vegetable garden at corner of Sargent Avenue and Spence Street.

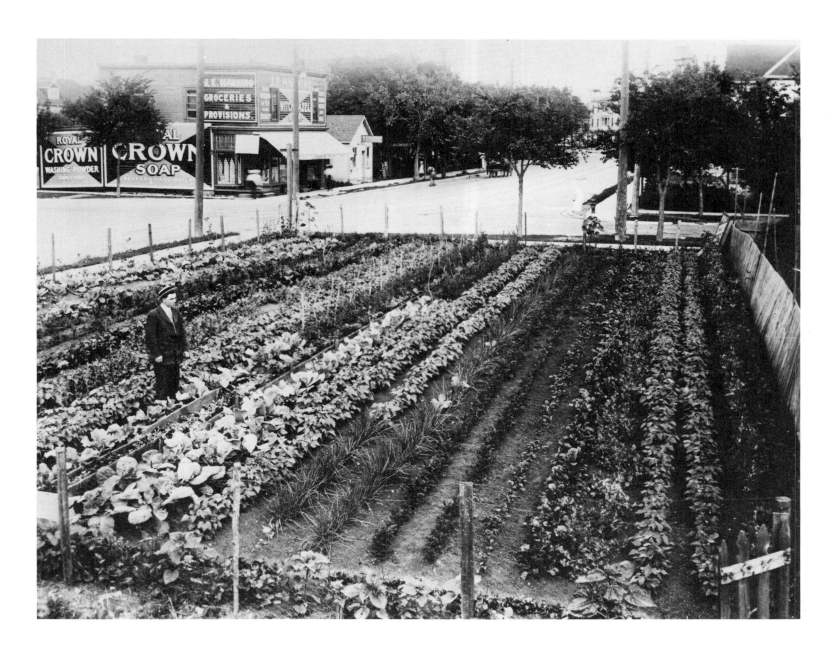

c. 1916. Lady preparing flax for agricultural exhibition.

July 4, 1923. C.N.I.B. Workshop.

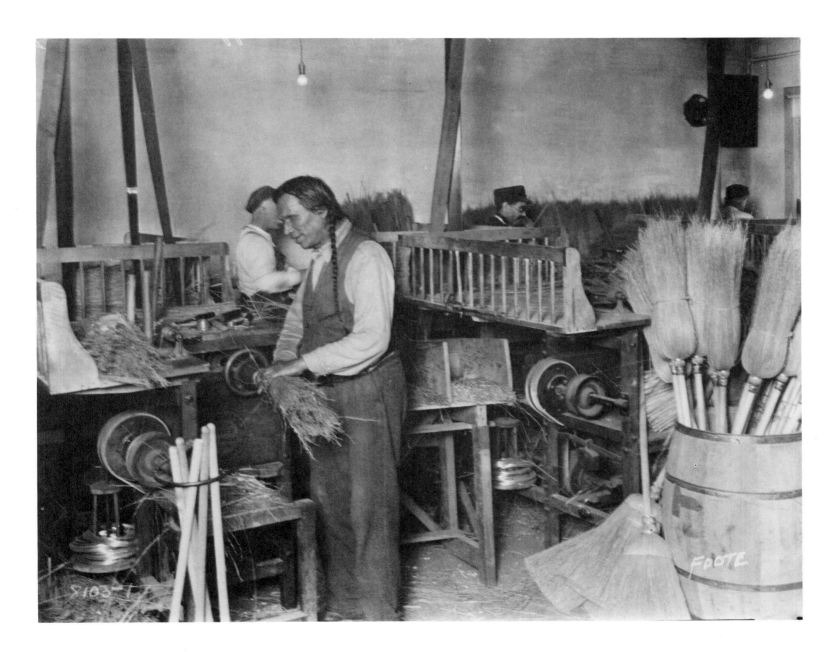

c. 1915. Moving a home with a team of horses.

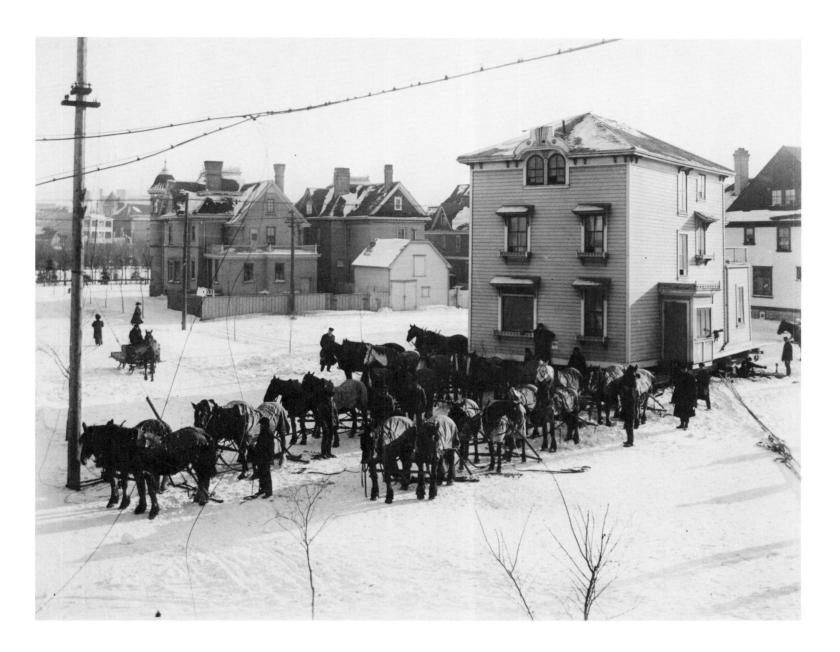

January 27, 1923. Wood supply for Greater Winnipeg Water District.

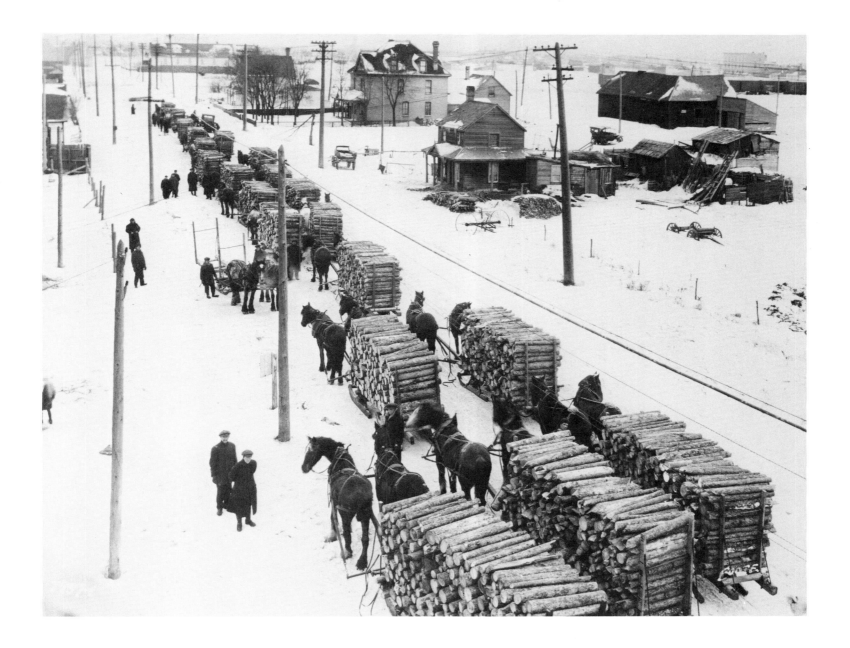

1914. Nurses and babies, Grace Hospital.

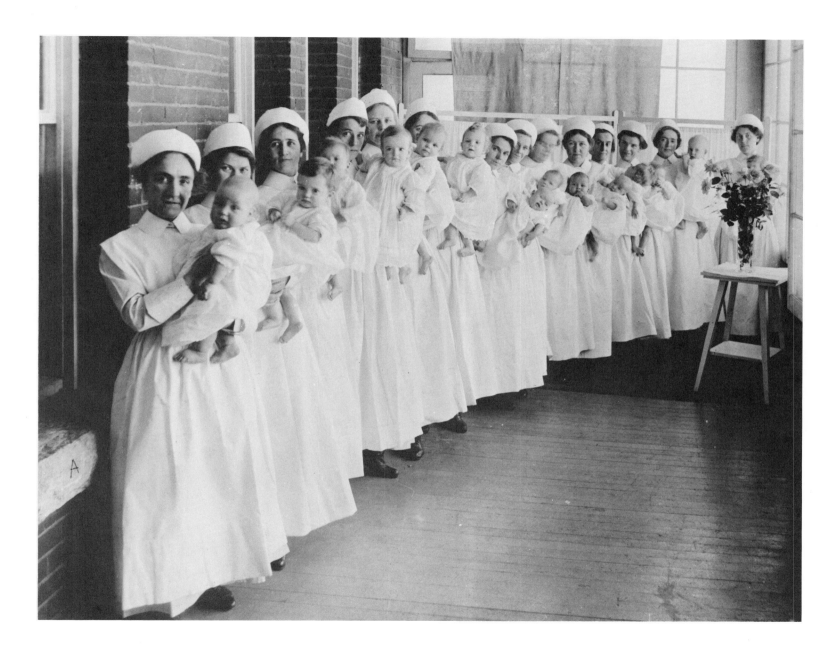

November 2, 1920. Party at Winchester Street, St. James.

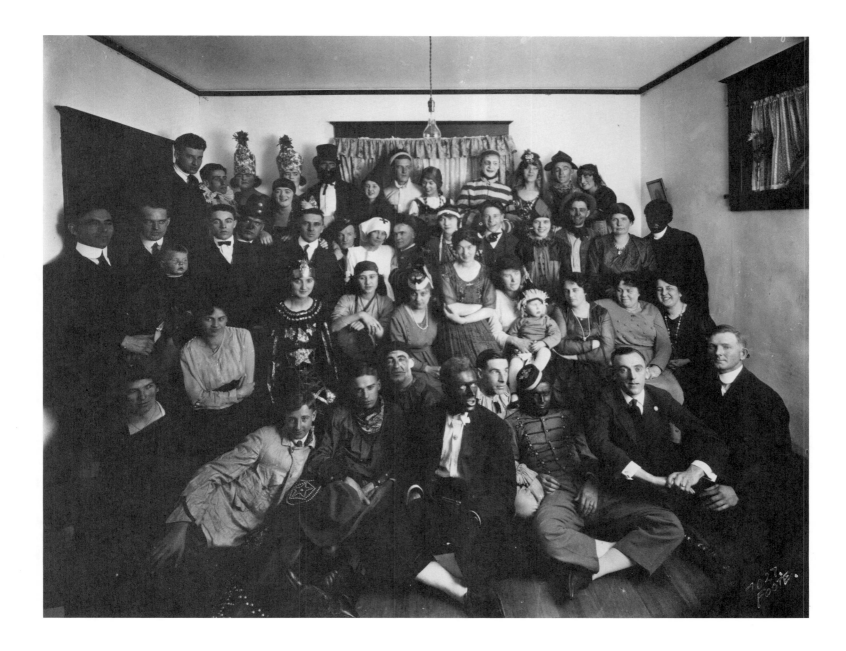

January 3, 1922. Interior of Granite Curling Club.

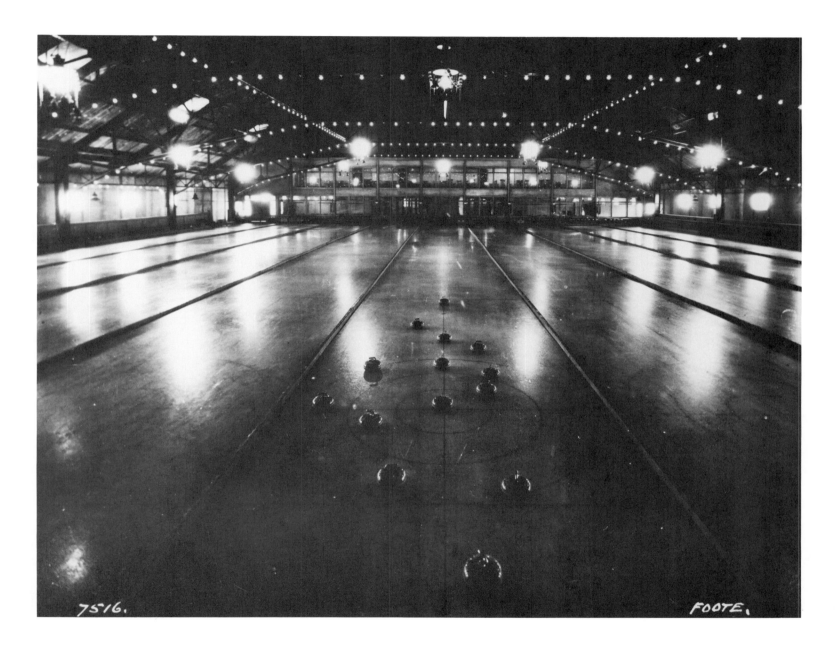

7516. FOOTE.

August 25, 1922. Don Wright band at L. B. Foote's house.

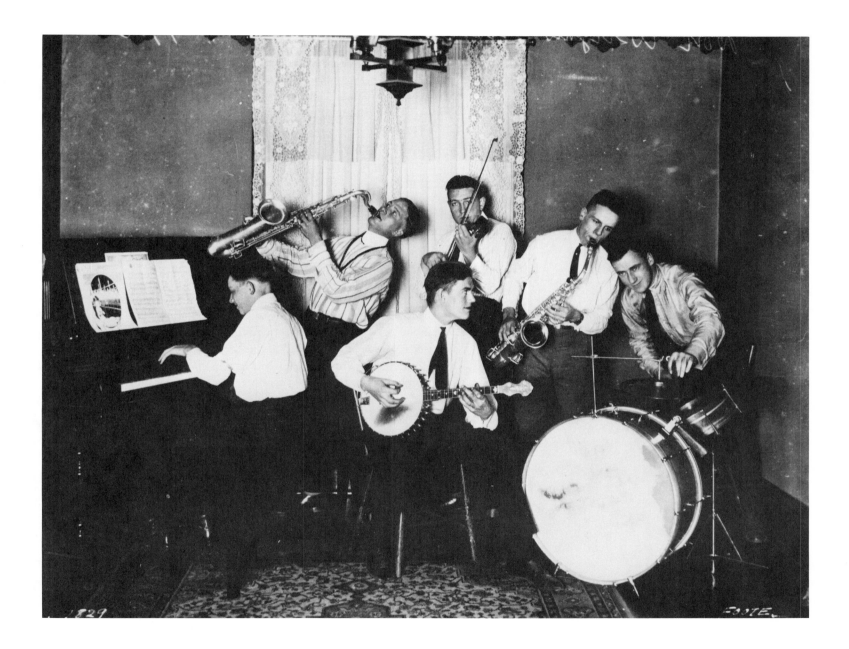

FIVE HOTELS ARE RAIDED BY POLICE
TEMPERANCE ACT ENFORCEMENT SQUAD BUSY OVER WEEK-END

Beer raids continued over the week-end and out of ten places visited by Inspector J.G. Neill and his squad of Temperance Act enforcement officers Saturday night, samples were taken from the Connaught, Corona, Manitoba, City and McLaren hotels. The samples were turned over to be analyzed.

An application was made before Mr. Justice Galt for a writ of habeas corpus in the case of Ben Funk, sentenced on March 5 to three months in jail by Magistrate Noble on a bootlegging charge. This was his second offence.

P.B. Pfrimmer, who applied for the writ, told the court that the sentence imposed on his client read with "hard labor." He contended that under the M.T.A. it was not legal to give hard labor on bootlegging charges. The argument will be heard on Thursday.

W. Dangerfield, Leland Hotel, was convicted by Magistrate Noble of keeping strong beer for sale. The crown endeavoured to prove that Dangerfield sold beer, but was not upheld by the bench. W. Noble, for the defence, contended that Dangerfield was not the licensee of the Leland Hotel; that the beer was found in the basement and that no evidence that it had been connected with the taps in the bar had been given, therefore Dangerfield could not be charged with selling. Magistrate Noble, in imposing a fine of $200 and the costs of the court, held that the strong beer being found in the basement of the hotel warranted him finding the accused guilty of having strong beer in his possession for sale.

Polly Chzanduski, 675 Selkirk Ave., was fined $200 and the costs of the court on a charge laid by Inspector Neill of having alcohol for sale. She was fined $200 and the costs of the court with the option of 60 days in jail.

—*The Winnipeg Evening Tribune* (Monday, April 23, 1923)

September 18, 1922. Still at 251 Boyd Avenue.

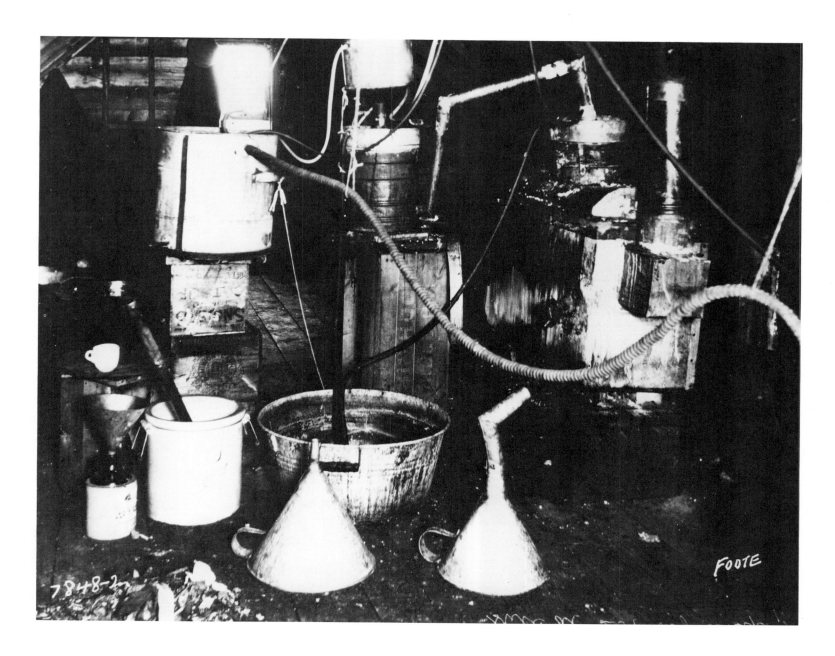

c. 1915. E. W. Darbey's Taxidermist store.

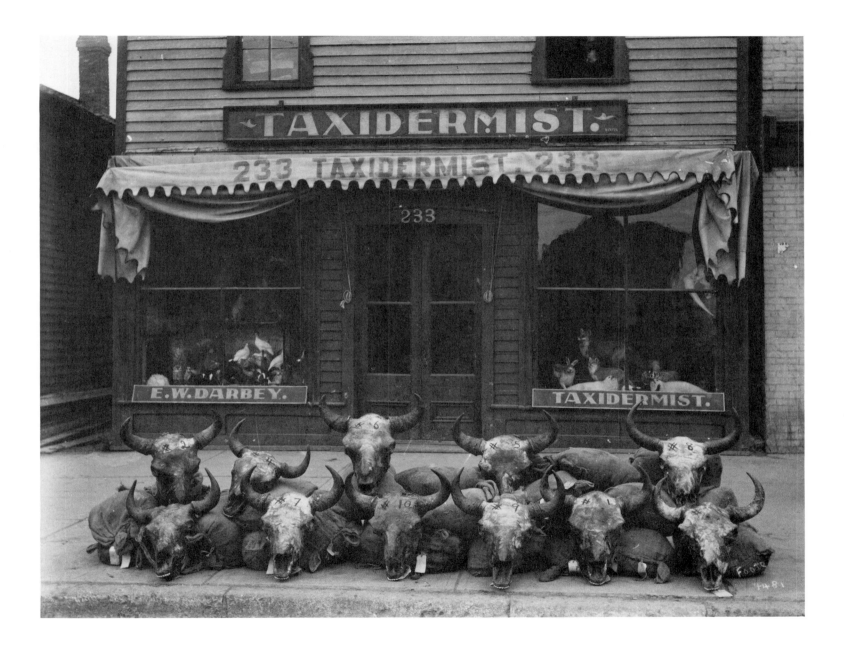

Harry Willis and Jeff Clark, the two husky black boys who are billed to mix it for ten rounds under the auspices of the Elks at the Ampitheatre rink arrived in the city on Saturday morning and put through some strenuous stunts in the preparation for the bout. Harry Willis, the next contender for the heavy-weight championship of the world, was a big attraction wherever he appeared during the past two days. Everybody seemed to recognize him by his size and his clean build. He looks every inch a champion; he worked out at the International club in St. Boniface and created a very favourable impression and those who have seen Dempsey in action say that the Negro has the class to give a champion a real argument.

—Winnipeg *Free Press* (Monday, July 17, 1922)

July 15, 1922. Harry Willis, boxer.

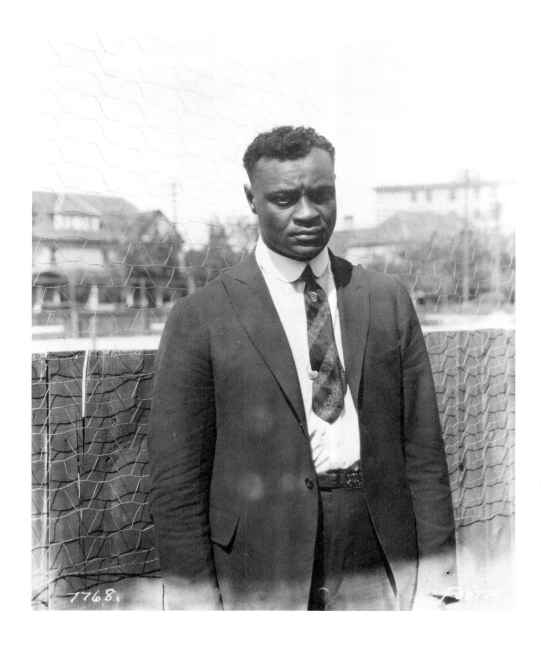

May 1920. Canoe race, Lockport to Winnipeg, Hudson's Bay Company Pageant.

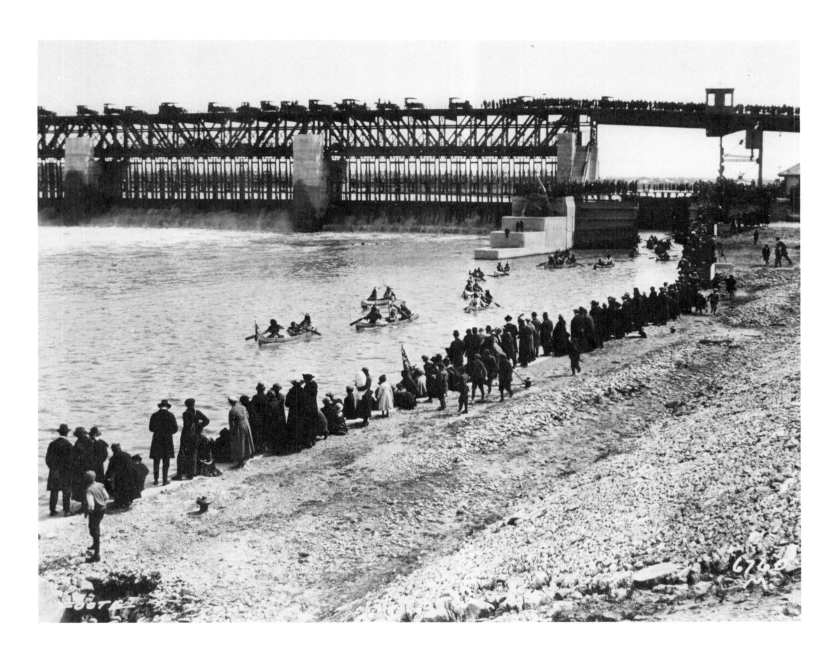

c. 1912. Lockport.

1914. Baseball player.

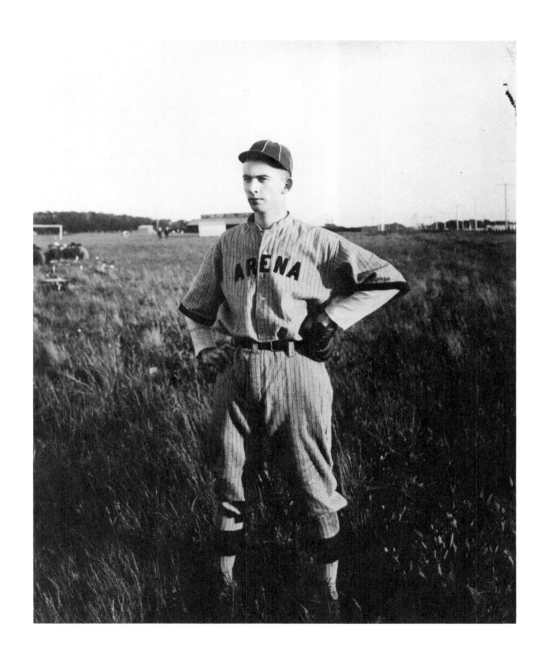

OUTFIELD IS IN NEED OF HAIRCUT

All scorers were lenient last night with outfielders Calhoun and McGraw. Under ordinary circumstances each would have been charged with an error. In the first inning Flaherty hit to center and the ball got past Calhoun. The same thing occurred with Wilkes' hit in the eighth, McGraw failing to stop the ball. The reasons both players were exempted from errors was due to the condition of the grass. No outfielder should be charged with an error on ground balls where Nature's hirsute is so long and flowing.

—*Winnipeg Tribune* (June 18, 1914)

c. 1920. Baseball games at Wesley Park.

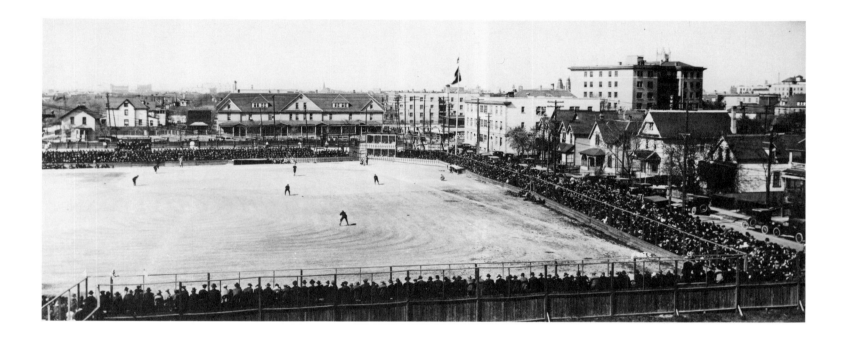

c. 1915. Geese.

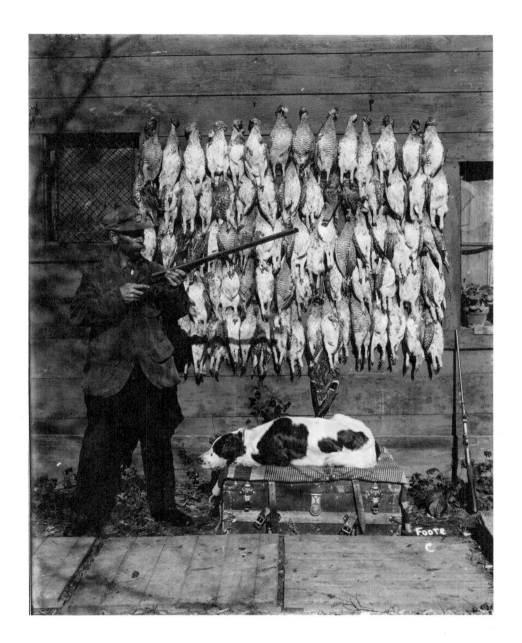

April 5, 1929. Girls' calisthenics class, Y.W.C.A.

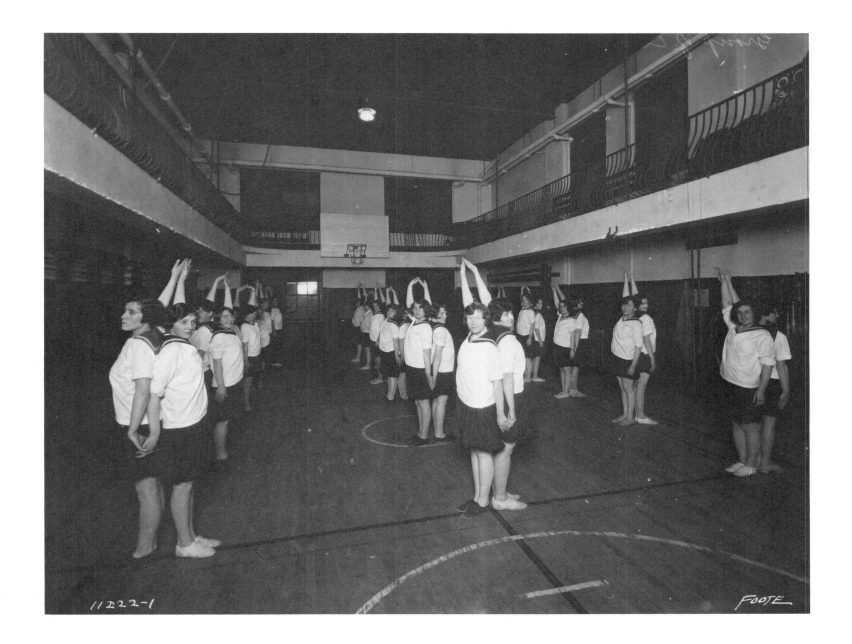

1916. Public health nursing demonstration and school class.

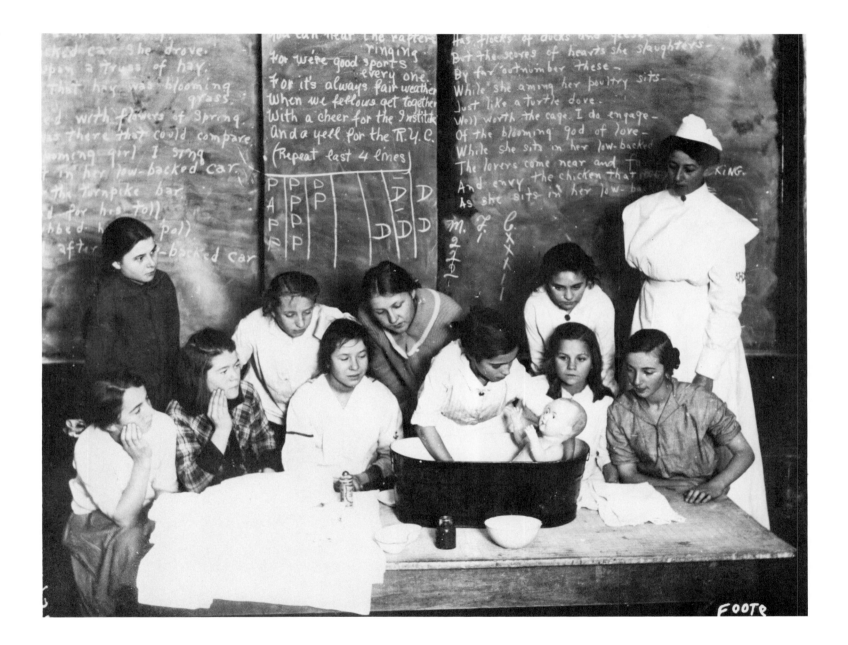

1910. Rev. Charles Gordon inspecting Boy Scout First Aid group.

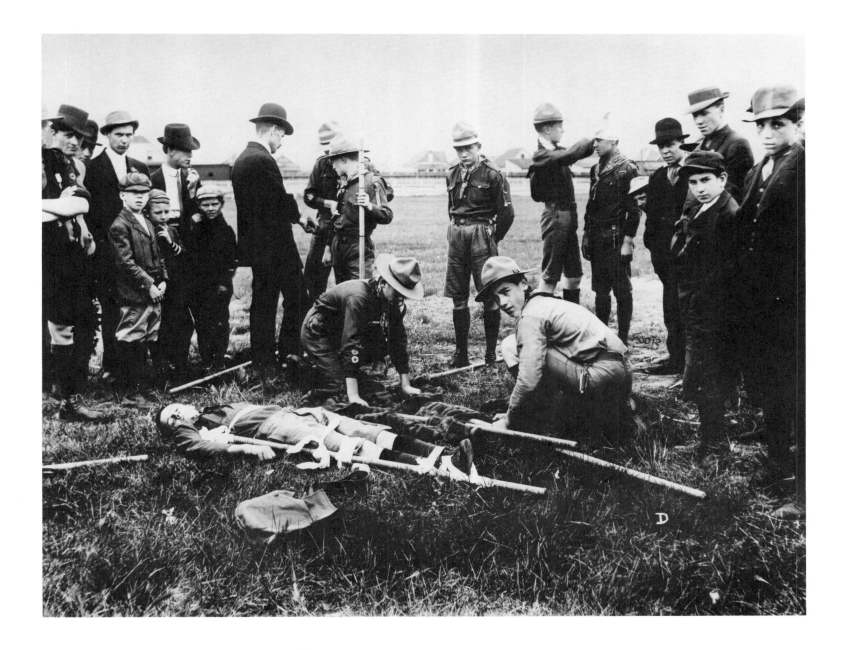

1912. Tractors and students, Manitoba Agricultural College, Tuxedo Site.

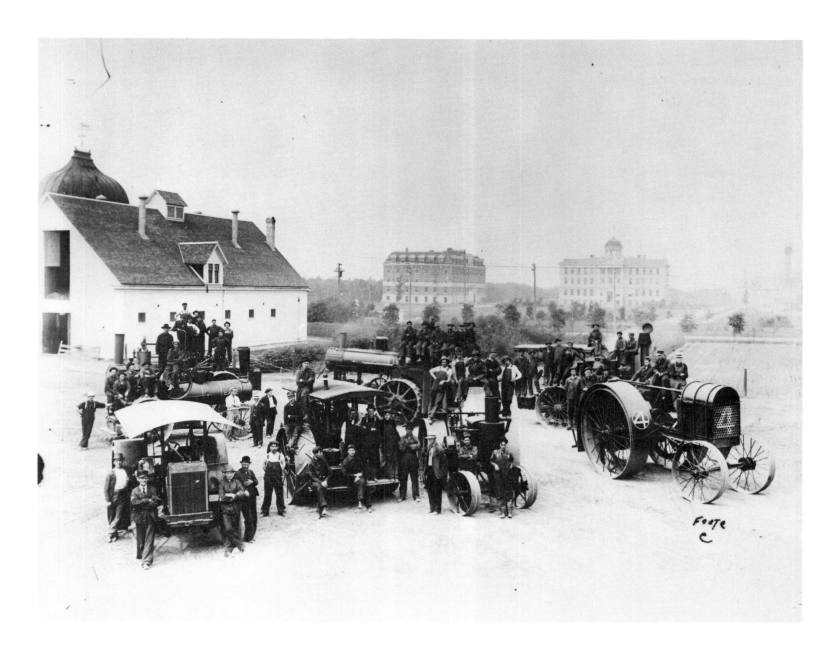

May 4, 1918. "Bicycle Bill."

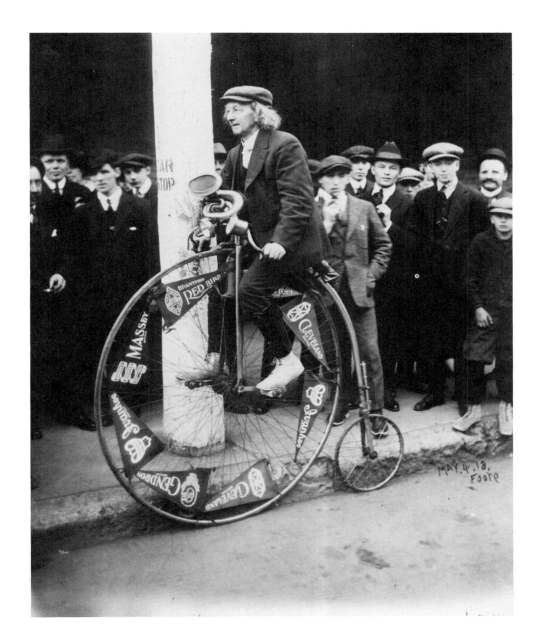

c. 1915. Winnipeg Canoe Club.

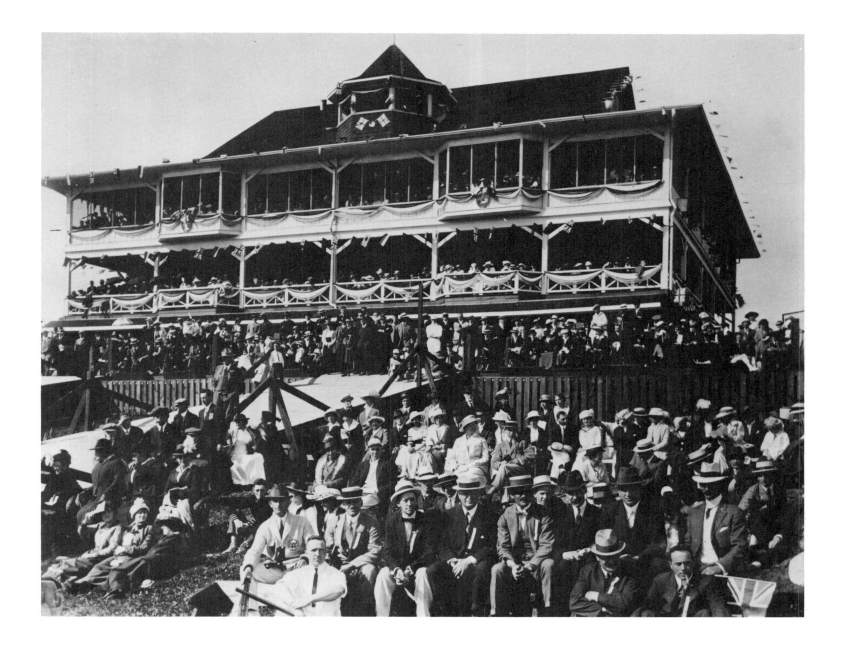

Gilbert Nason had been one of the men whose belief in the future of the city was as firm as their belief in God, and ten times more profitable. In fact, while his faith in the Almighty had wavered more than once when he had trouble with Labour Unions, he could not recall one investment in real estate that had failed to vindicate his faith in the good sense and the vision that had prompted him to make it.

—Douglas Durkin, *The Magpie* (University of Toronto Press, 1928)

June, 1927. Arthur A. Bovin and family, 6 East Gate.

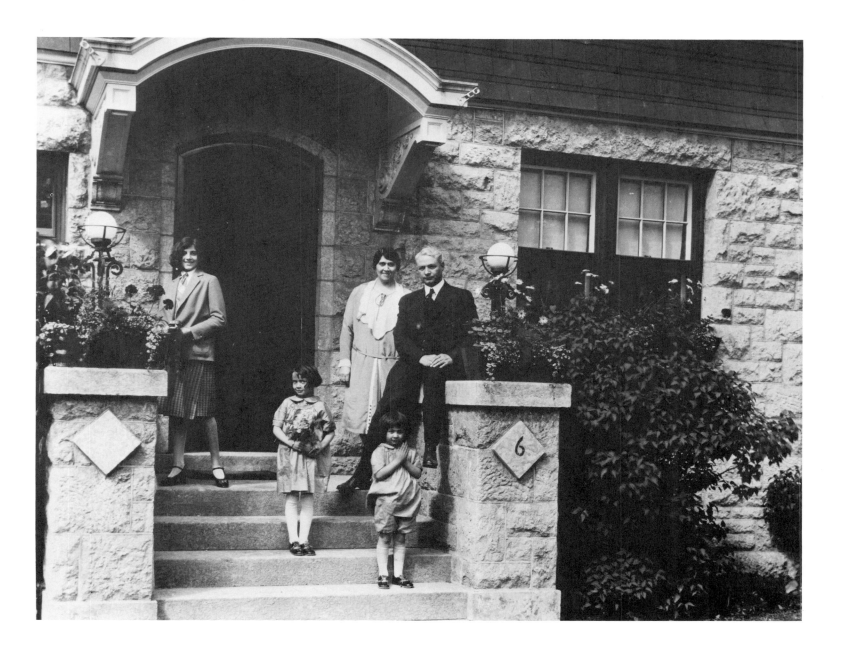

January 29, 1924. Arctic Ice Co. employees "testing the water."

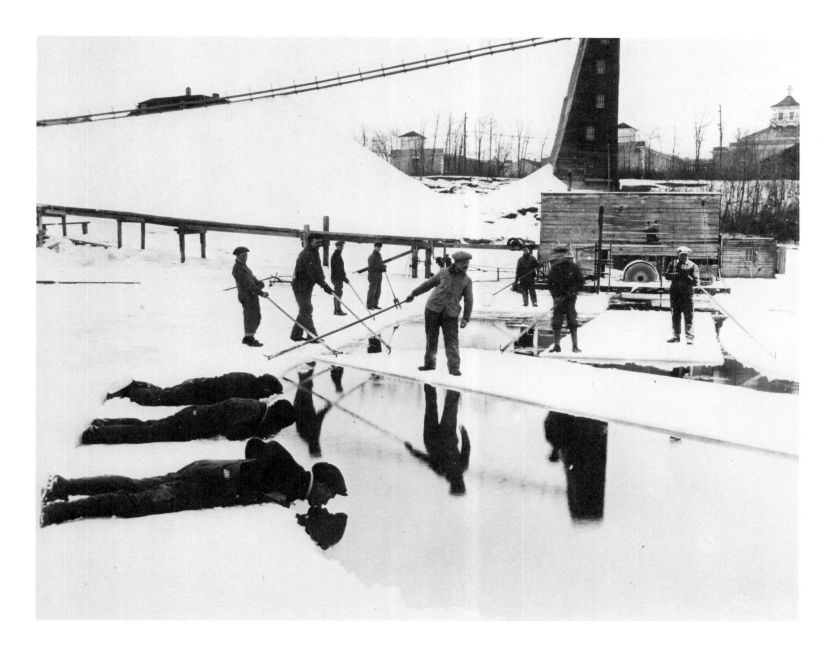

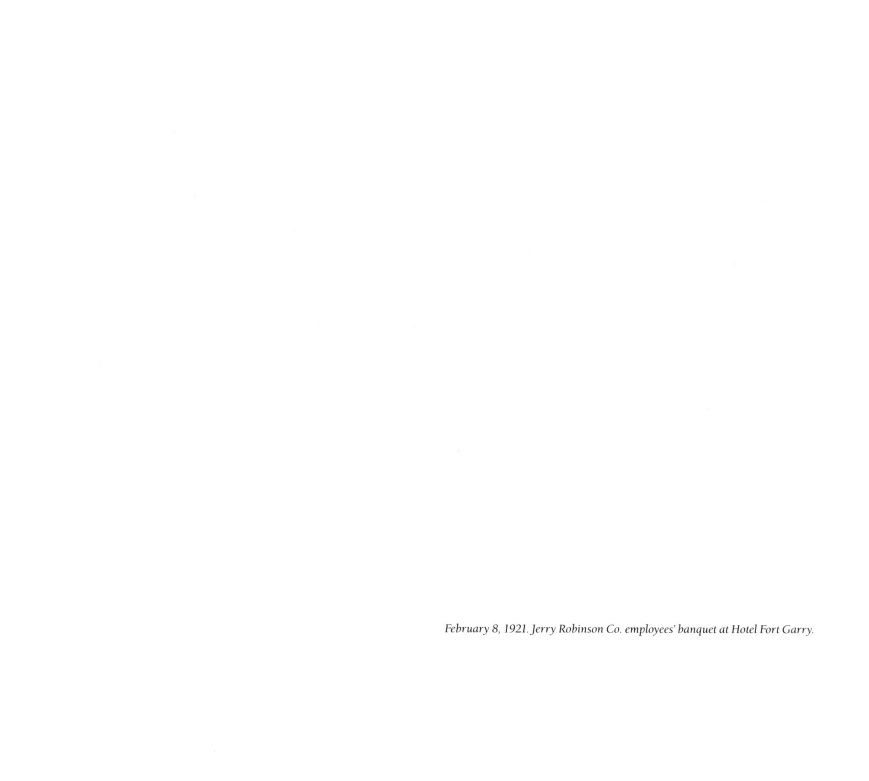

February 8, 1921. Jerry Robinson Co. employees' banquet at Hotel Fort Garry.

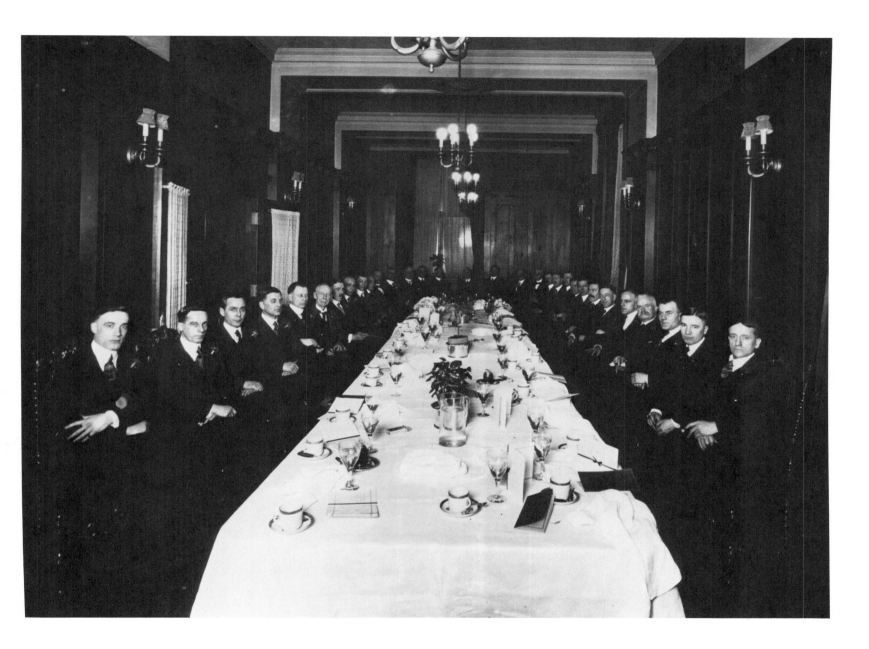

August 20, 1944. John Hanz with son and daughter.

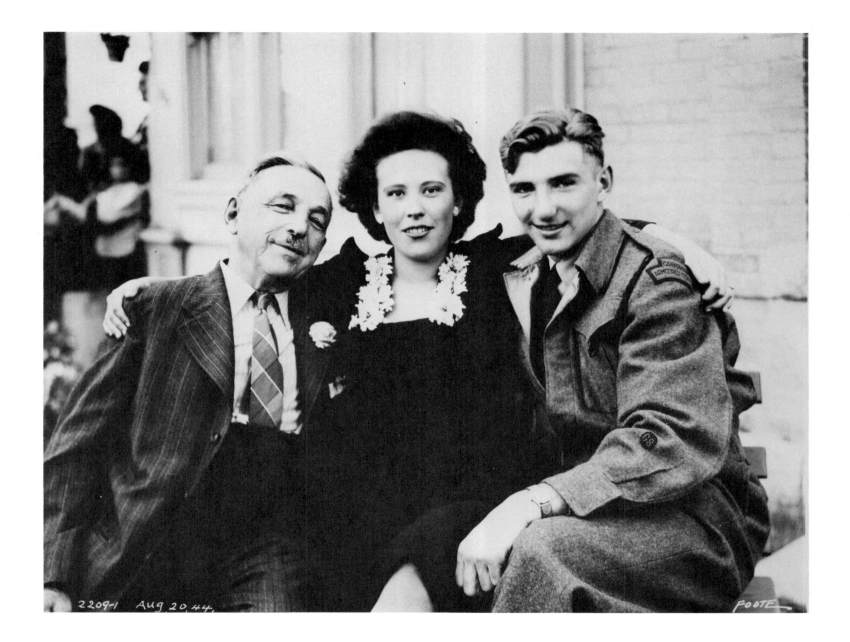

I believe women suffrage would be a retrograde movement, that it would break up the home, and that it would throw the children into the arms of the servant girls.

—Sir Rodmond Roblin

c. 1915. Minstrel show, Votes for Women. ·

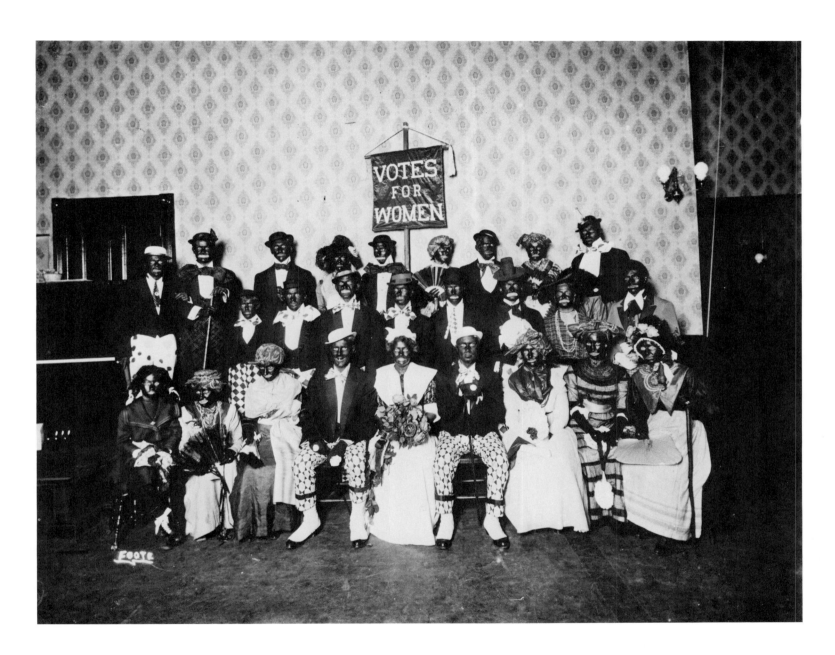

Every newspaper except their own was suppressed; water pressure was reduced to thirty pounds, for that is enough to bring it to one storey buildings, and the *Western Labor News* stated that it is in one storey buildings that the "workers" live, the inference being that it did not matter whether the other people lived or not.

There was something so despotic and arrogant about all this, that even indifferent citizens rallied to the call for help.

—Nellie McClung, unpublished memoir

May, 1919. Women volunteers at gas station during Winnipeg General Strike.

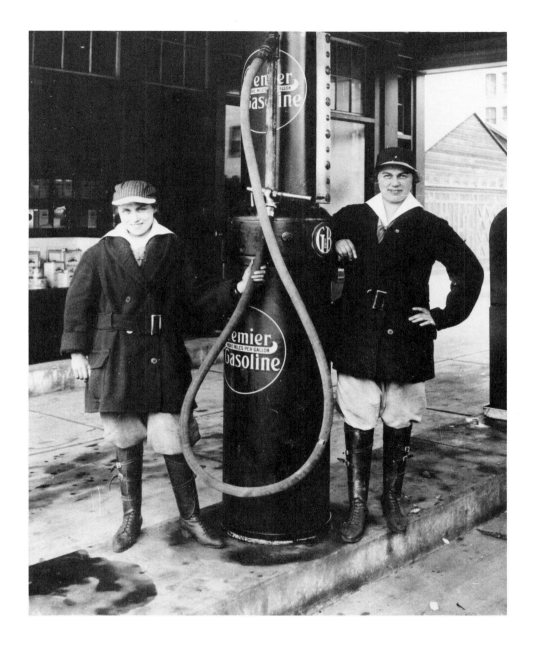

Woe unto them that decree unrighteous decrees, and that write grievousness which they have prescribed; to turn aside the needy from judgment, and to take away the right from the poor of my people that widows may be their prey and that they may rob the fatherless.

—*Isaiah*

June 21, 1919. Winnipeg General Strike.

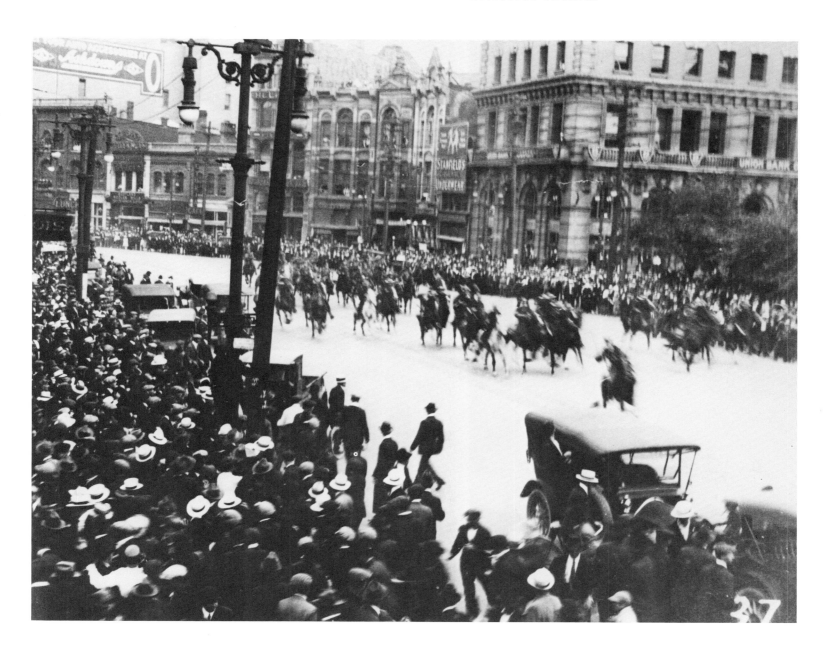

June, 1919. Winnipeg Strike. Headquarters of the Citizens Committee of One Thousand.

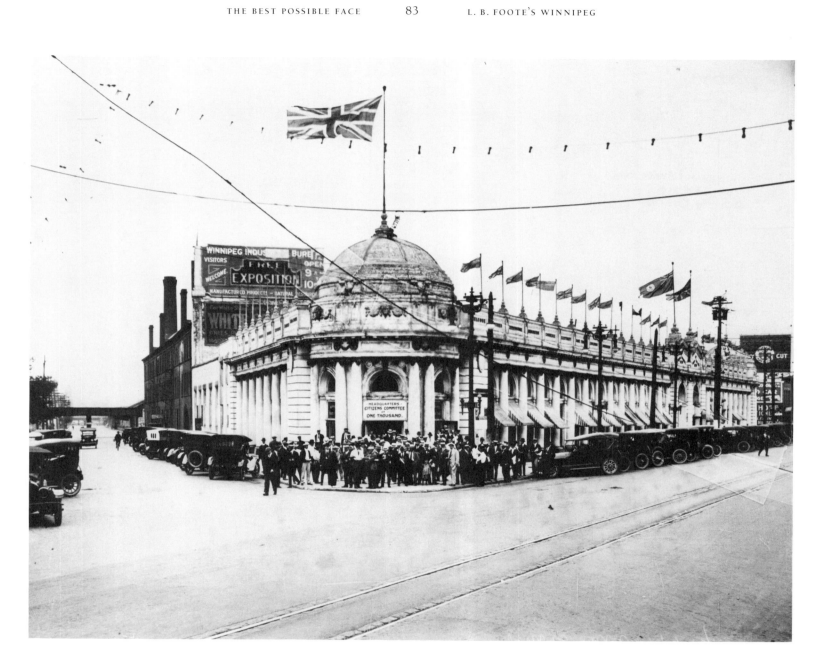

Richard Bray: "At the present time the most dangerous person in the City, in view of the fact that he is a Returned Soldier and is using this to influence other Returned men."

—report of secret agent of the RNWMP

June 13, 1919. Meeting at Victoria Park. Speaker is R. Ernest Bray.

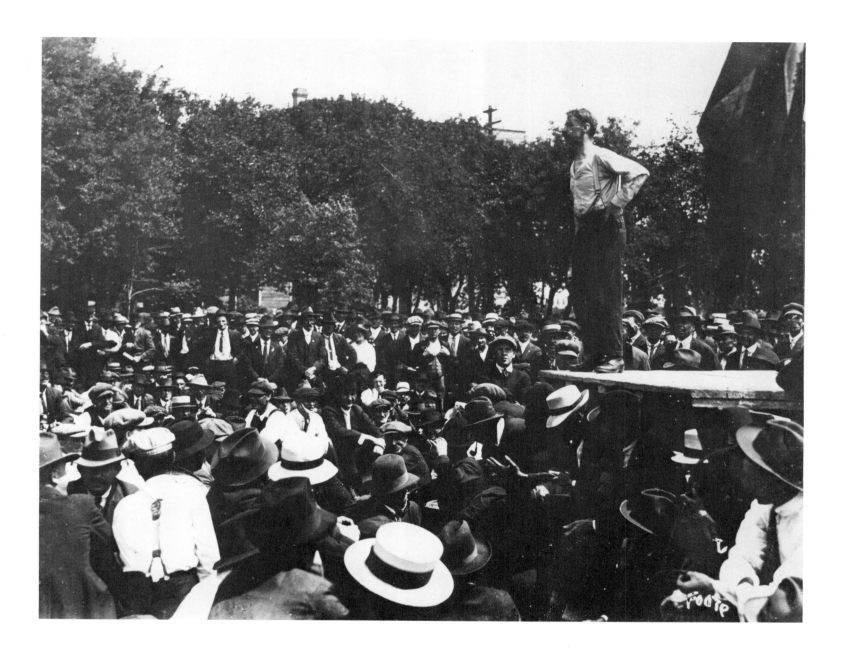

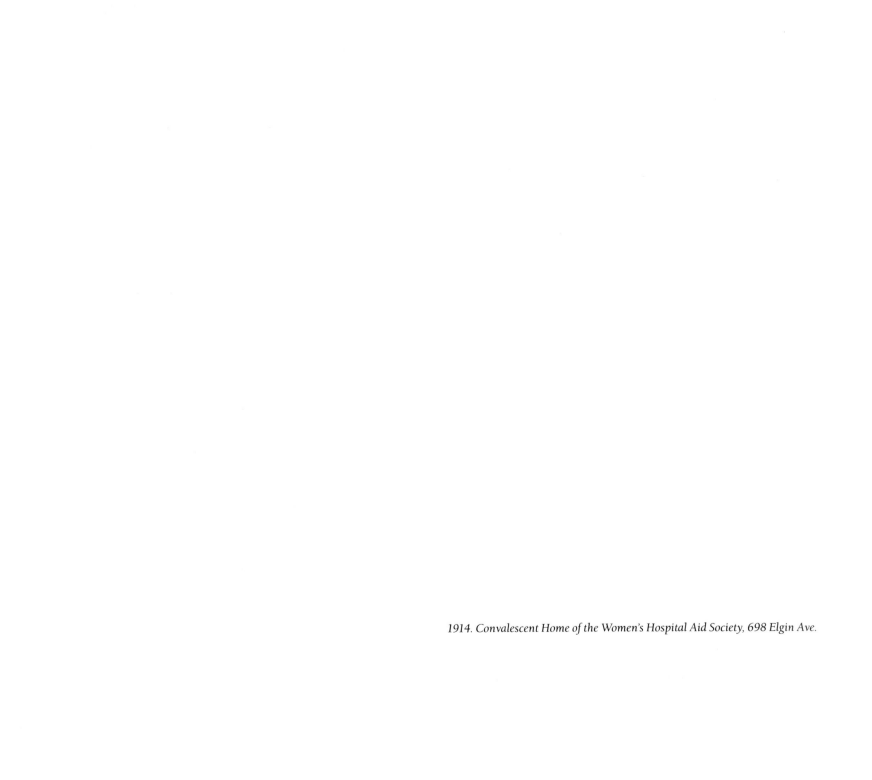

1914. Convalescent Home of the Women's Hospital Aid Society, 698 Elgin Ave.

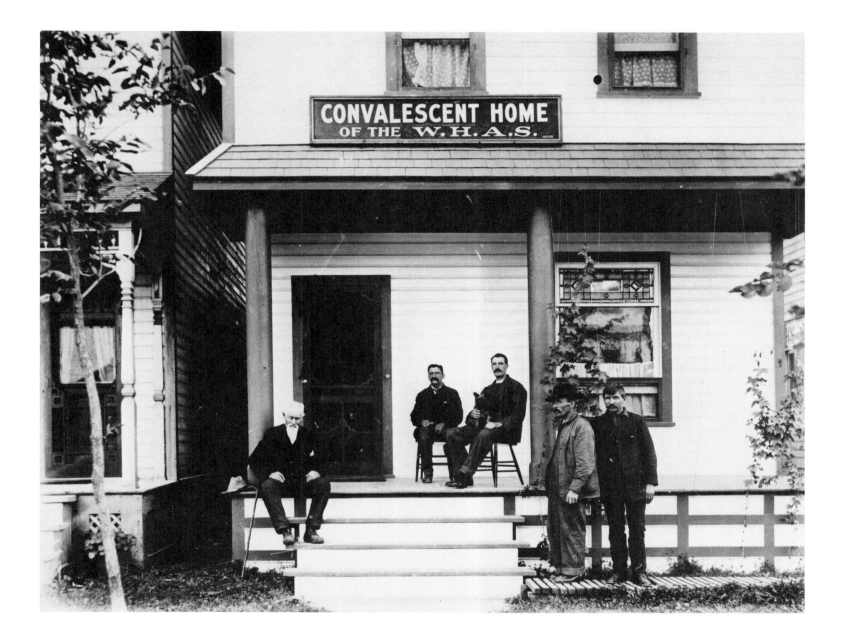

WHICH LABEL DO YOU PREFER:
BILL THE BOOB OR WM. THE USELESS?
SELECTION OF FITTING TITLE FOR HUN KAISER
PROVES POPULAR DIVERSION

What's in a name?

Lots, thinks the Hun Kaiser who wants to be known to posterity as William the Great, but who has a string of aliases including everything from "The Devil's Masterpiece" to "Bill the Baby Killer," and with such appellations strung in as "The Anti-Christ," "Bill the Boob" and "William the Useless."

Evidence that readers of the *Tribune* do not regard William the Great as a fitting moniker for Gott's senior partner is not lacking. Scores of replies are forthcoming in answer to the inquiry "What's the Kaiser's right label?" And in every instance those who are re-christening "The King with the Withered Arm and Shrivelled Soul" differ with him as to what he should be called by succeeding generations.

—*The Winnipeg Evening Tribune* (June 21, 1918)

1918. Wood, Valence Wholesale Company employees during Armistice celebrations.

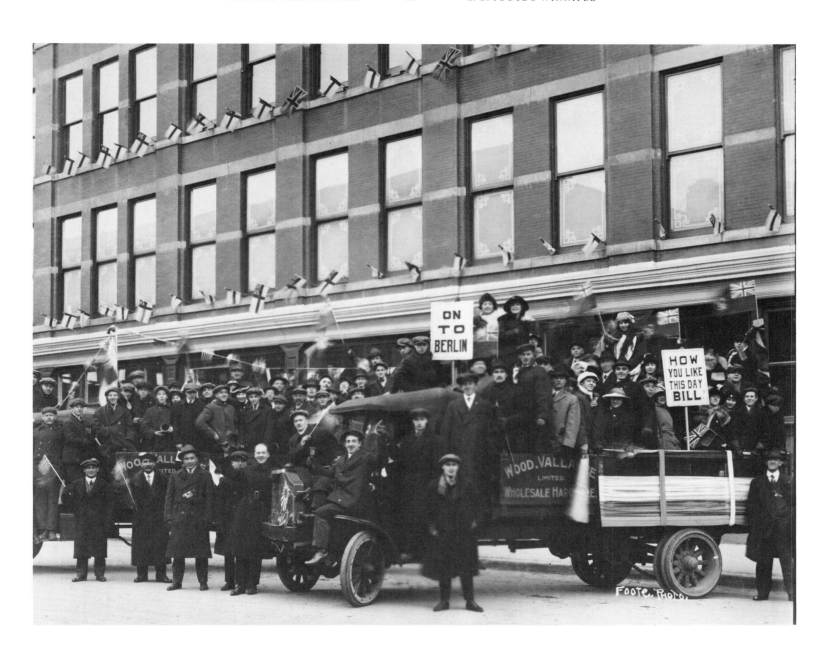

One day, in the path of the retreating Germans, he had come upon trees denuded of their bark and left to die. He had touched their bleeding trunks with his fingers and stood while the sadness in his heart turned to bitterness and then to hatred. As he turned away pride in the Great Adventure vanished from his heart.

—Douglas Durkin, *The Magpie* (University of Toronto Press, 1928)

1916. Recruiting drive, trenches at Main Street and Water Avenue.

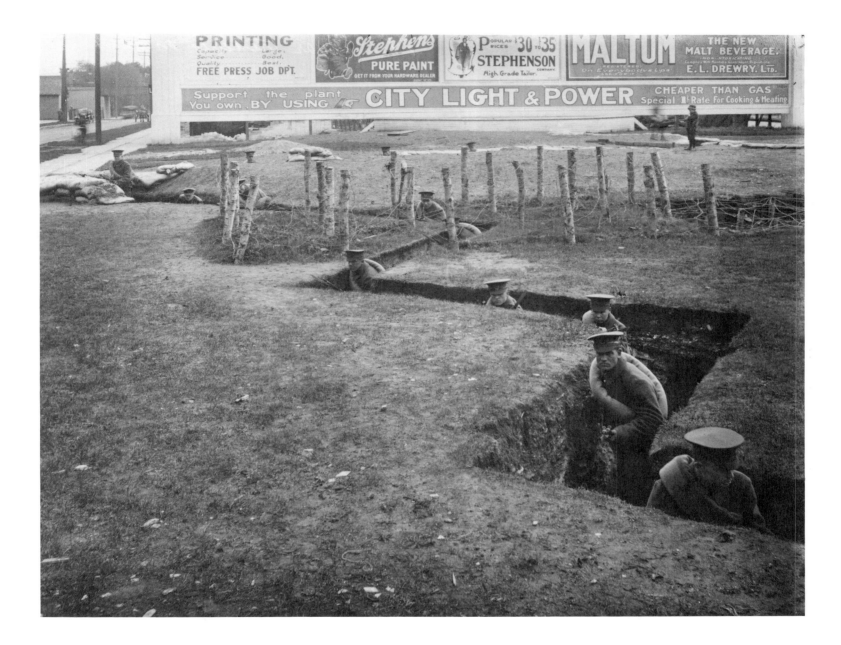

May 7, 1945. V. E. Day, corner of Portage Avenue and Main Street.

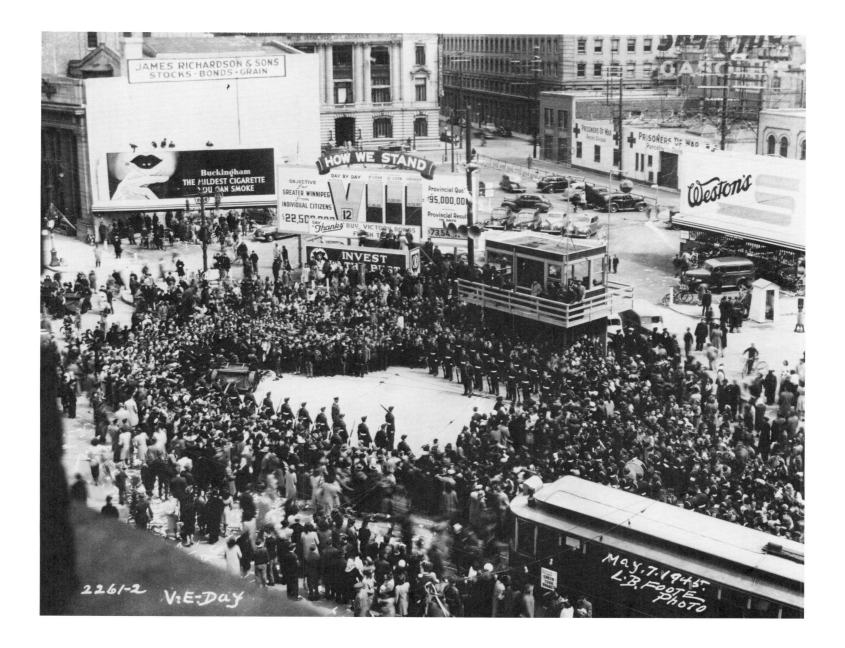

This is an English-speaking province and it is the duty of the government to see that every pupil of the public schools is given a sufficient education in English to equip him, in part at least, for the business of life.

We must Canadianize this generation of foreign-born settlers, or this will cease to be a Canadian country in any real sense of the term.

—John W. Dafoe, from W. Isajiw, *Identities* (PMA, 1977)

March, 1938. Aberdeen School children representing 21 nationalities.

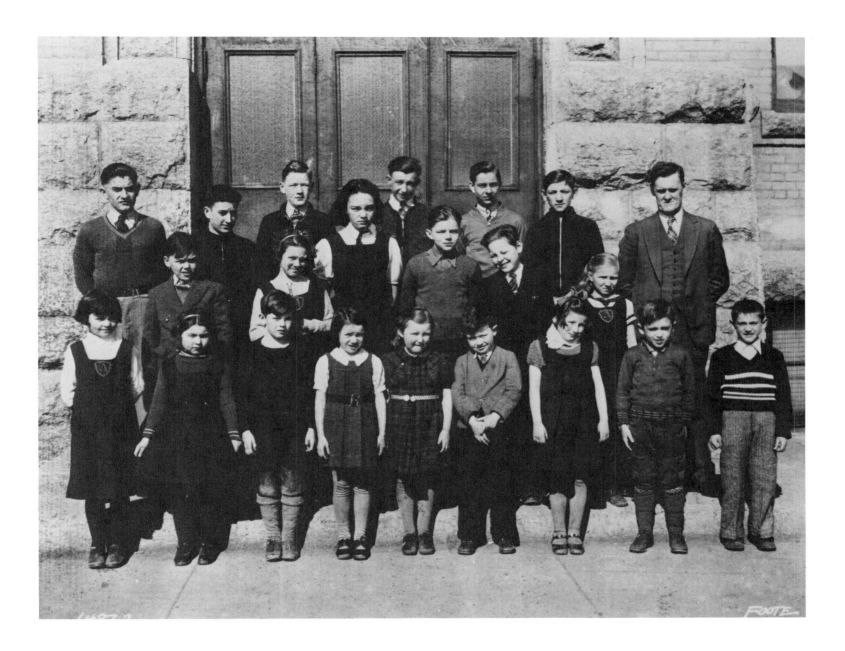

c. 1906-1910. Old man with newspaper in front of a slum dwelling.

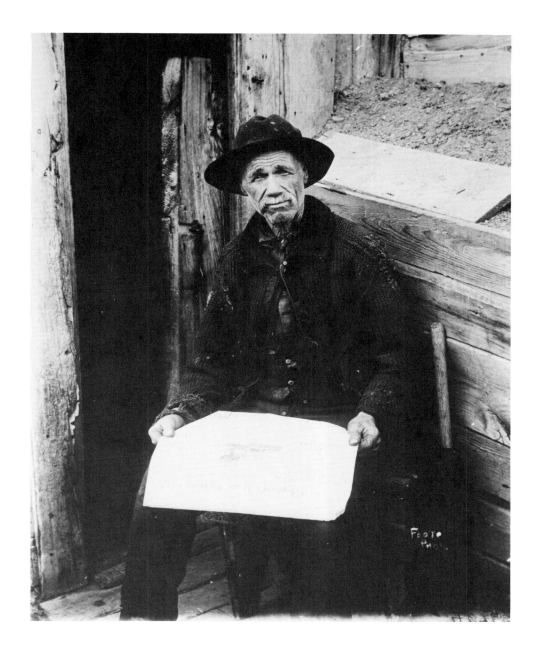

What does the ordinary Canadian know about our immigrants? He classifies all men as white men and foreigners. The foreigners he thinks of as the men who dig the sewers and get into trouble at the police court. They are all supposed to dress in outlandish garb, to speak a barbarian tongue, and to smell abominably.

—J.S. Woodsworth, *Strangers Within our Gates*
(University of Toronto Press, 1909)

c. 1915. Immigrant family.

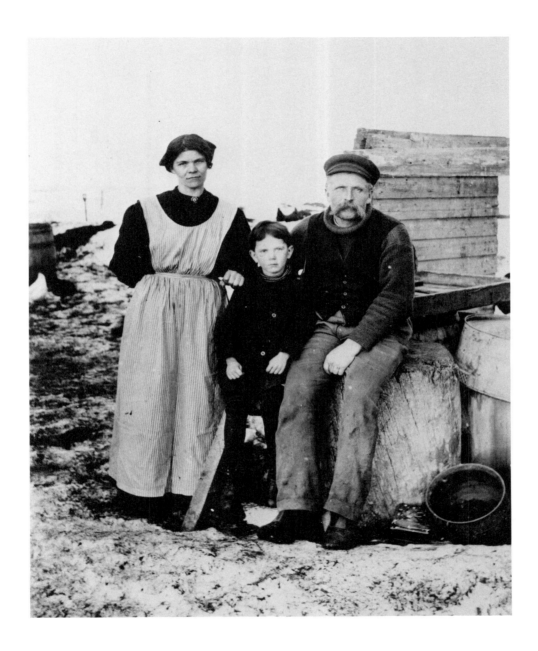

c. 1915. Interior of slum home.

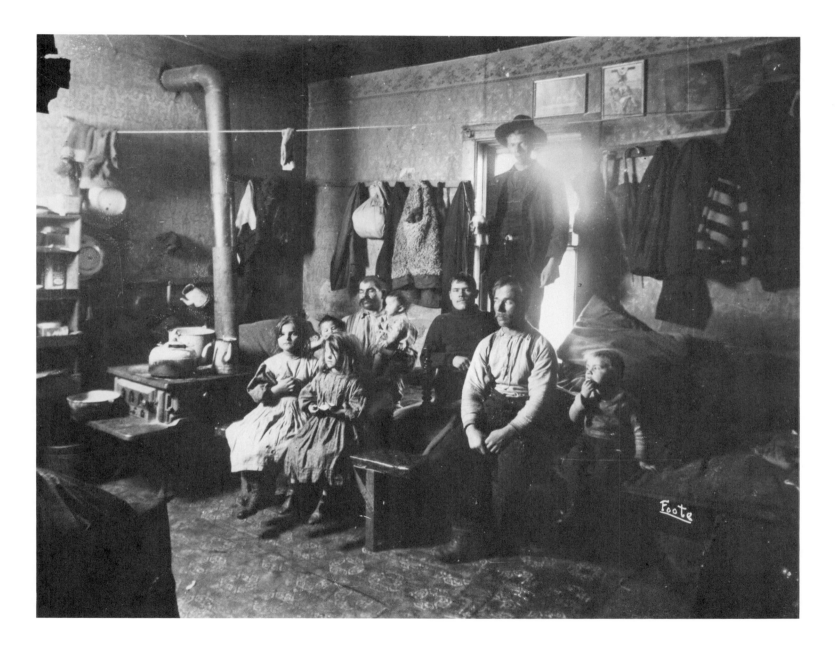

TWO YOUTHS FACE TRIAL FOR MURDER;
BOTH LESS THAN 20 YEARS OF AGE

John Stoike, 19 years old, charged with complicity in the murder of Constable Bernard W. Snowdon, of the city police force was placed on trial this afternoon before Mr. Justice Metcalf.

Trial of Mike Podolczuk, 15 years old, charged with the murder of an aged woodsman named Marcie, likely will be commenced Wednesday morning before Mr. Justice Galt.

—*Winnipeg Tribune* (July 2, 1918)

July, 1918. Boys captured for murder that took place on Greater Winnipeg Water District.

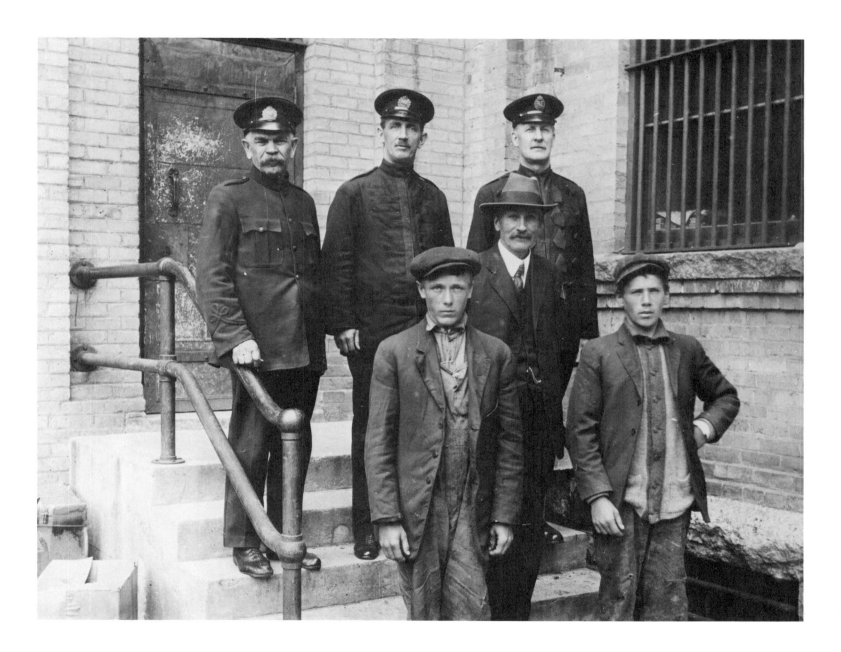

March, 1919. Remains of gypsy woman at Bardal Funeral Home.

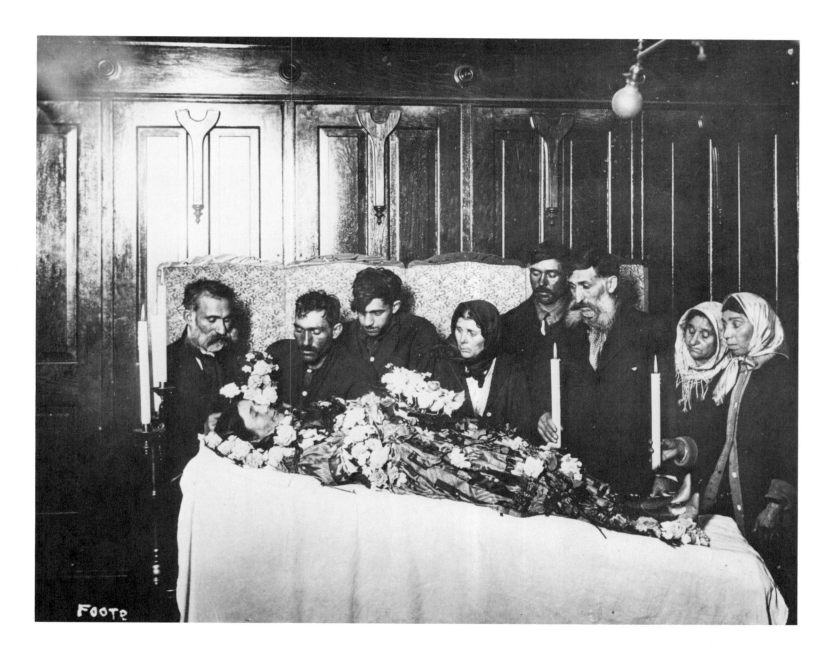

Mrs. Frances Allen, wife of Joseph Allen, bartender at the Wellington Hotel, was found dead in the kitchen of her home, 82 Cobourg Street at 10 o'clock last night. It was her brother-in-law, Bert Allen, who had called upon her, who made the discovery. The woman was fully dressed as if about to leave her home when stricken. Indications were that she had been dead for several hours. The milk delivered by the dairyman was standing at the back door. At the front door was a new hat for which, according to the invoice, $17 had been paid, had been delivered from the T. Eaton company's store. The house was fully lighted. Dr. McConnell, provincial coroner, Inspector Street of the central police division, Acting Inspector Bishop of the detective department, Sergt. Donald, Detective Sergt. Hoskins and other officers assisted in the lengthy investigation. Nothing was found to suggest violence. Dr. McConnell stated that a post mortem examination would be made today to determine the cause of the woman's death.

—*Manitoba Free Press* (Friday, October 21, 1921)

October 20, 1921. Remains of Mrs. James A. Allan, 83 Cobourg Street.

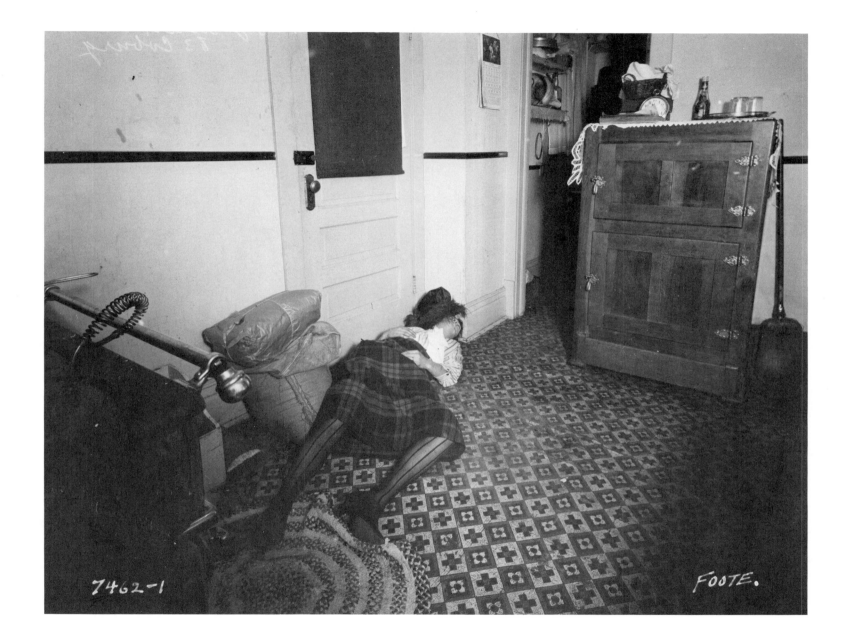

Those who remember the institution of the Little White Hearse, which was commonplace on the streets of old Winnipeg, know the frequency of those epidemics and their fatal virulence. Those were the good old days when every mother was warned against 'the second summer' for her baby.

—Laura Goodman Salverson, *Confessions of an Immigrant's Daughter* (University of Toronto Press, 1926)

c. 1914. Group of children and child's coffin.

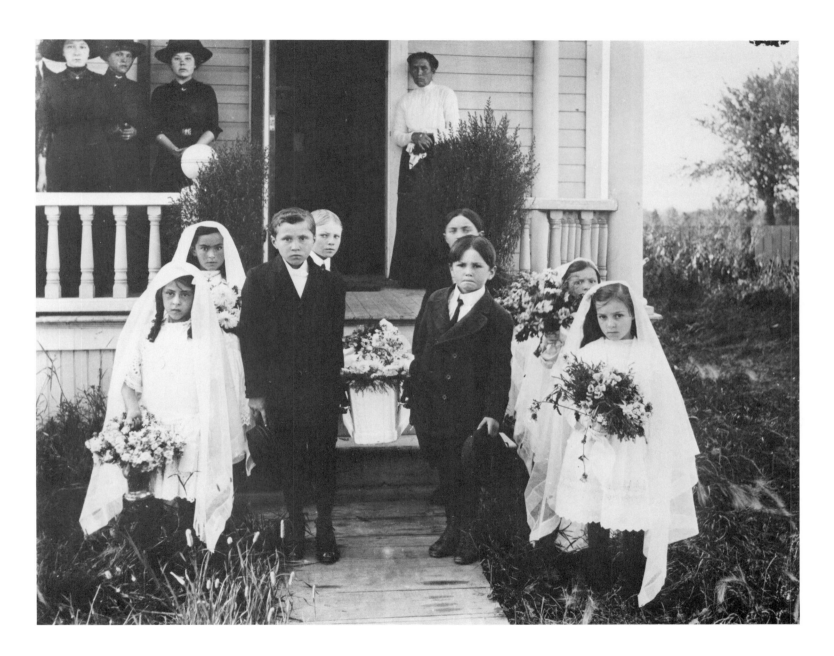

October 19, 1910. Mr. and Mrs. Andre Nault, St. Vital, Manitoba.
Diamond Anniversary party.

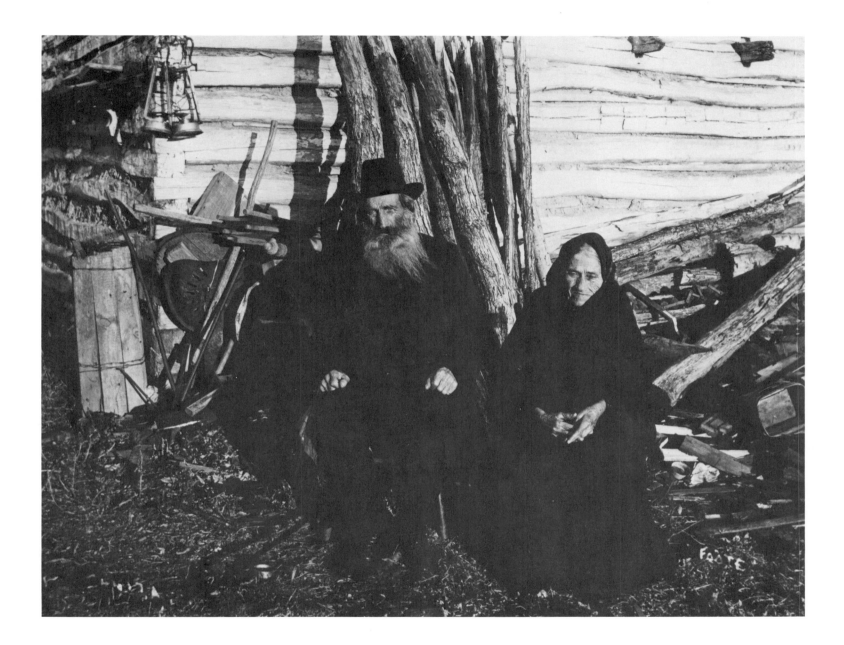

c. 1915. Indian mother and child on boat,·northern Manitoba.

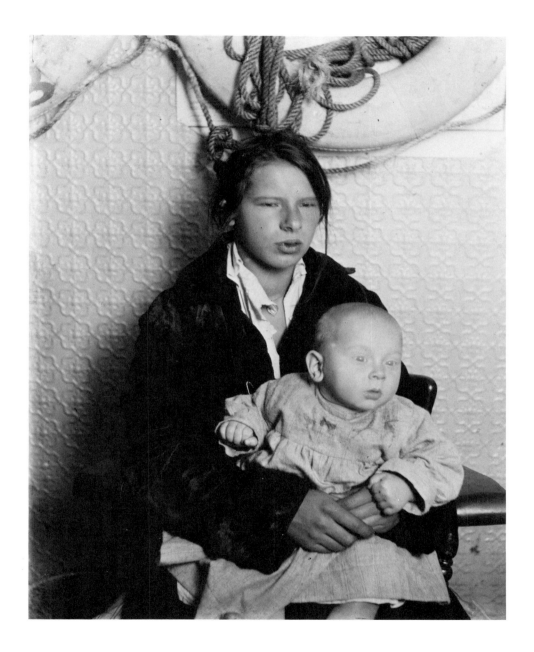

1921. Interior of the Grain Exchange.

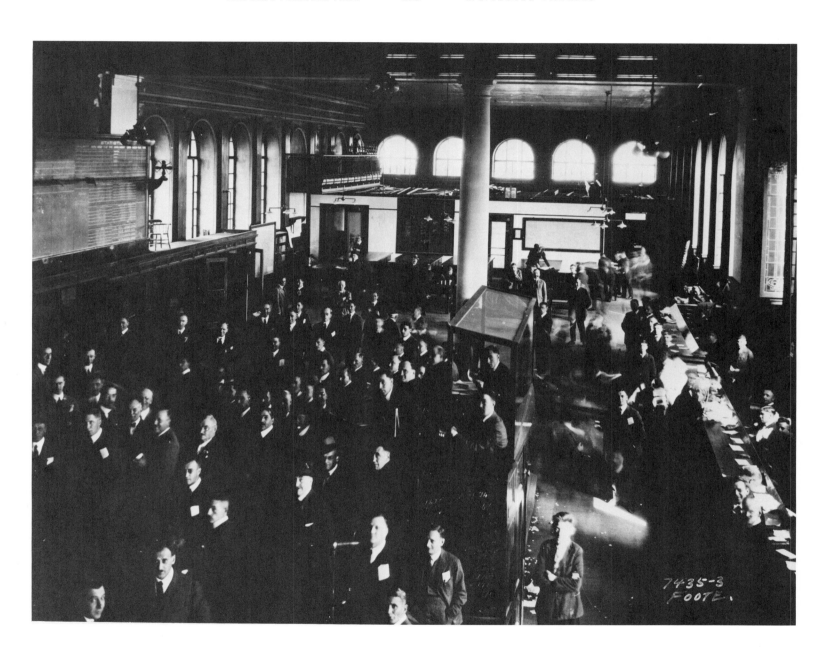

1917. Mrs. A. C. Ross and daughters.

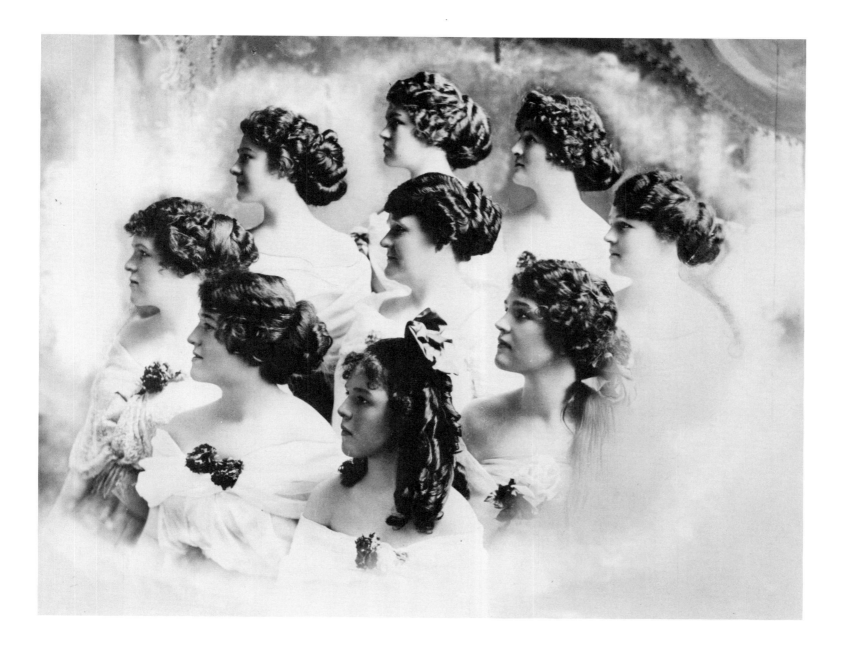

c. 1910. Telegram Printing Company Building, 244 McDermot Avenue.

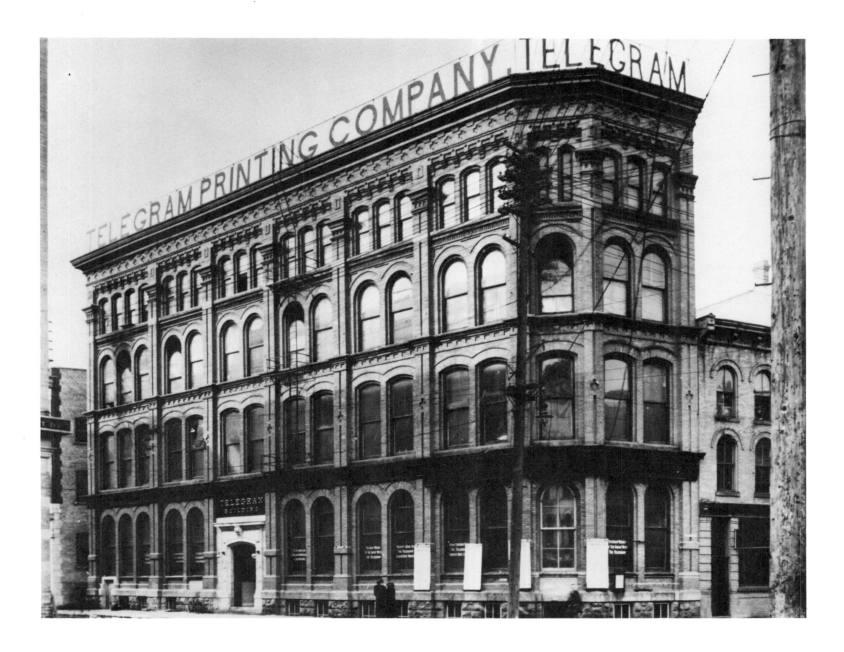

July, 1914. Interior, Winnipeg Telegram.

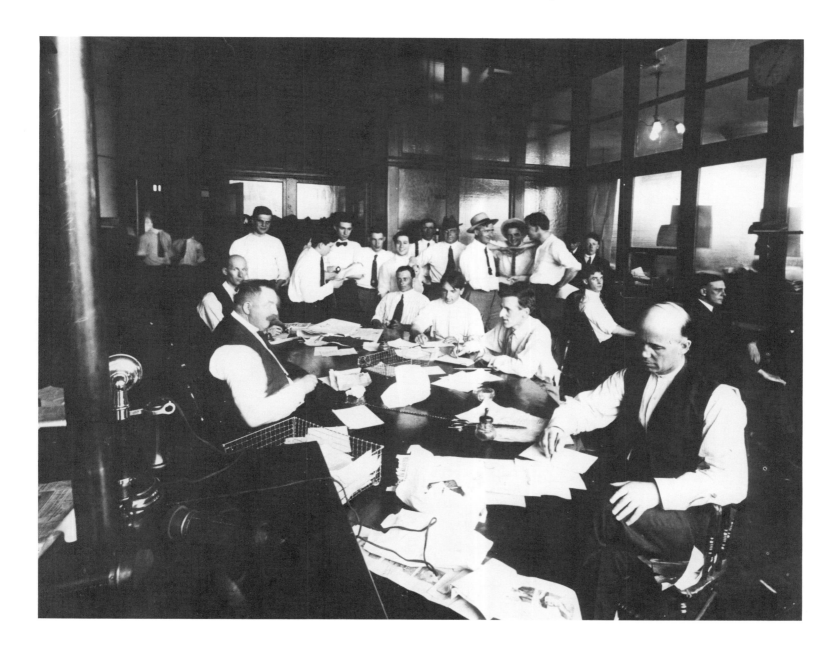

Let a man get filled up with wheat, and you could get nothing
else into him, tho' you offered him heaven.

—C. W. Gordon, *Methodist Magazine and Review*, 56
(July-December, 1902)

*January 5, 1931. Inauguration of high-speed ticker tape at the
Winnipeg Grain Exchange.*

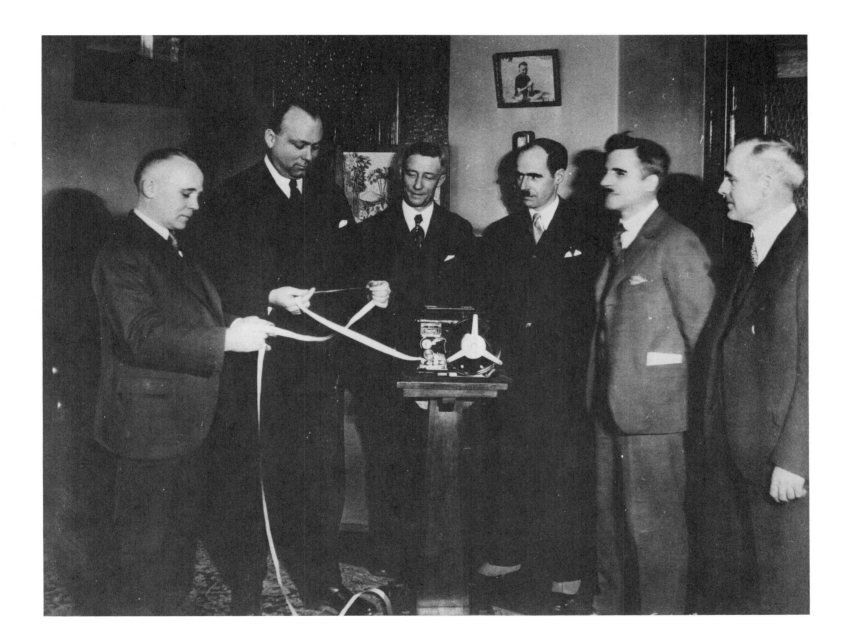

1918. Union Bank of Canada, Main Street at William.
(Note man climbing building.)

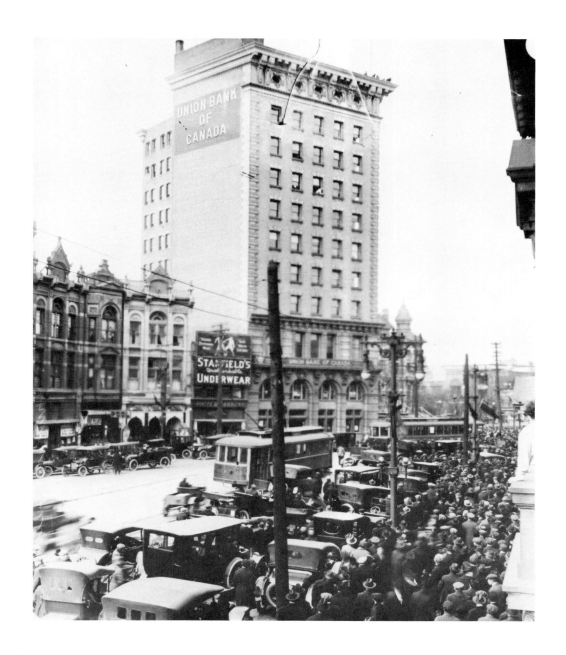

"All right, Foote, I'll put it on."

1921. Prince of Wales on board S.S. Princess Alice, *Victoria Harbour.*

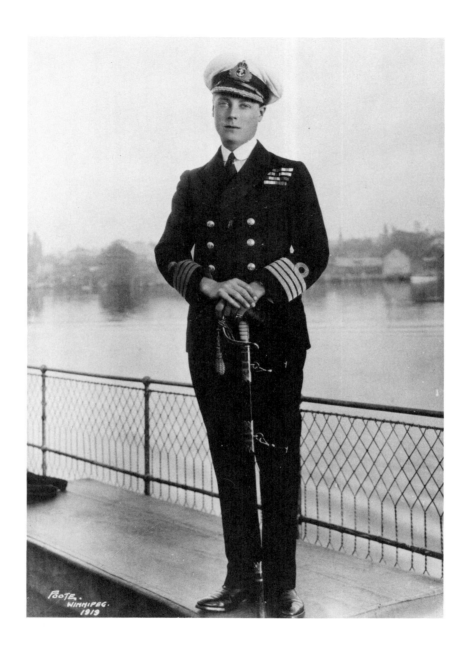

1913. Visit of George VI and Queen Elizabeth.

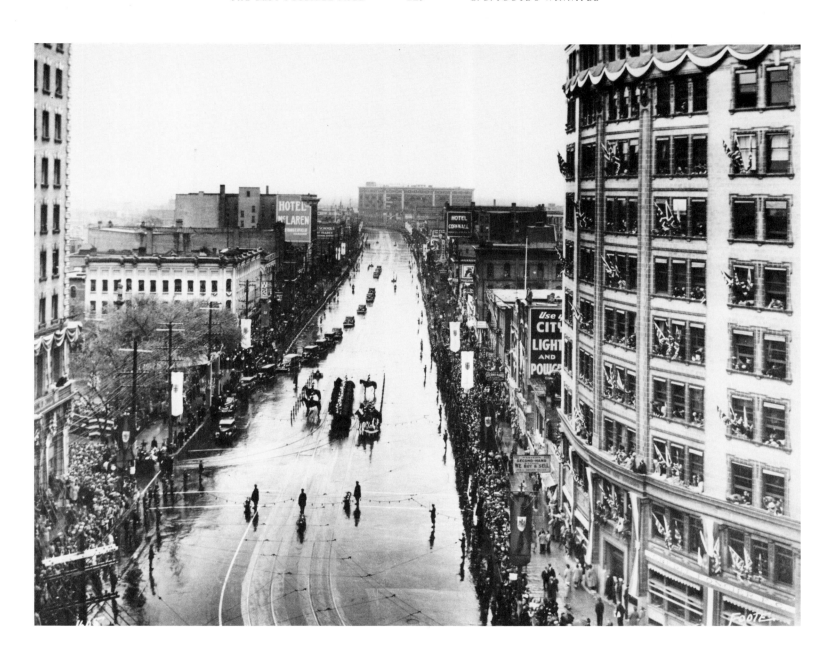

Sir:

In view of the information gathered in the last few weeks by the Public Works Department, and the statement made by Ex-Judge Phippen before the Royal Commission, there is no doubt that Mr. A.B. Hudson had substantial justification for his statements regarding overpayments etc., in connection with the erection of the New Parliament Buildings.

The Government constitutionally being responsible for the action of their officials in matters of this kind, I feel that it is incumbent upon me to resign my position as Premier of this Province, which I now do, and would respectfully recommend that Mr. T.C. Norris, M.P.P., leader of the Opposition, be called upon to form a new government.

—Sir Rodmond Roblin, May 12, 1915

c. 1913. "Manitoba," centrepiece of the pediment.

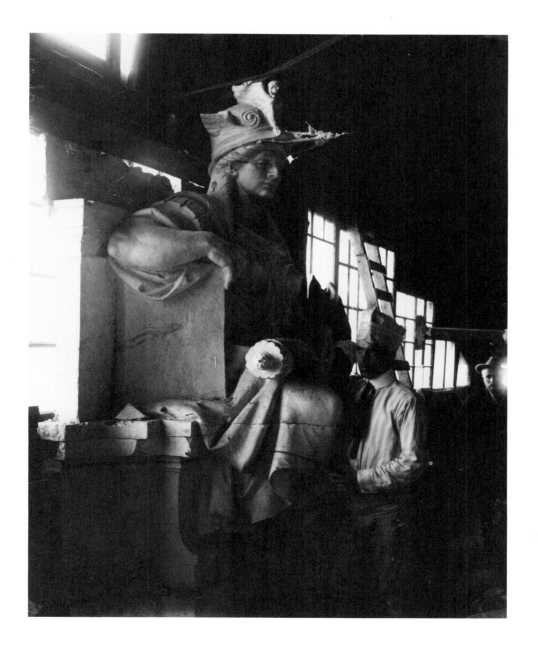

c. 1916. Catholic Order of Foresters.

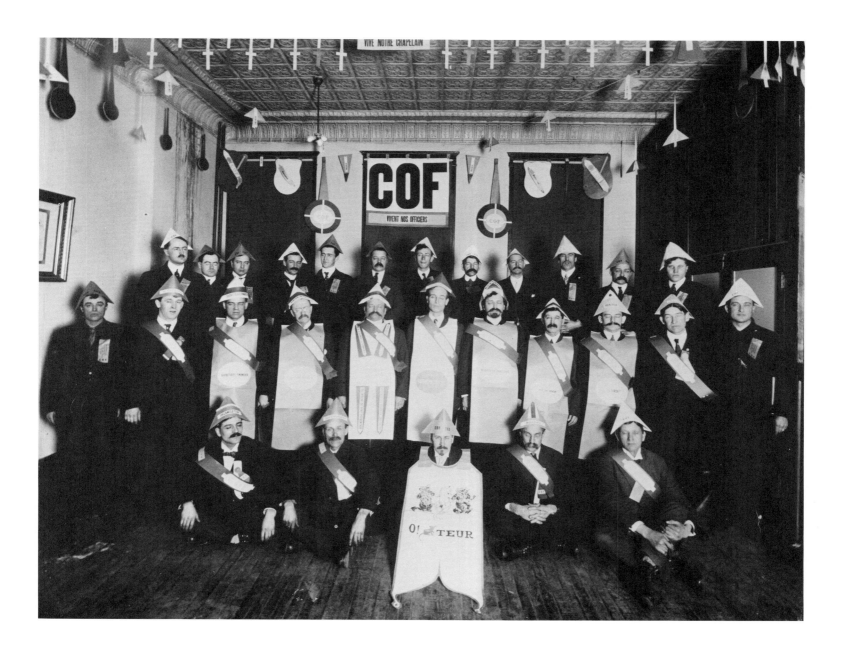

1921. Midget and giant, C. A. Wortham Circus.

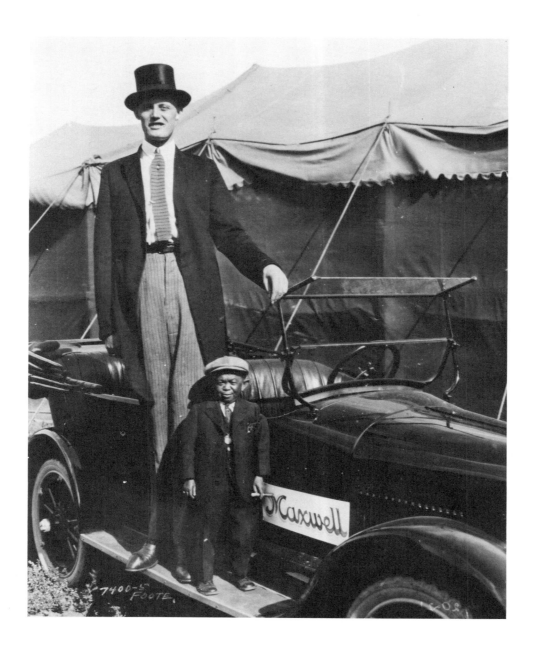